SOUTH ST. PAUL

SOUTH ST. PAUL

A BRIEF HISTORY

Lois A. Glewwe

Published by The History Press
Charleston, SC
www.historypress.net

Copyright © 2015 by Lois A. Glewwe
All rights reserved

Front cover, bottom: Exchange Building. *Kelly Rae Vo, photographer.*
Back cover, top: Train. *Reinhold O. Werner photograph collection*; *bottom*: Aerial view of South St. Paul, 1945. *Dakota County Historical Society.*

First published 2015

Manufactured in the United States

ISBN 978.1.62619.881.4

Library of Congress Control Number: 2015951453

Notice: The information in this book is true and complete to the best of our knowledge. It is offered without guarantee on the part of the author or The History Press. The author and The History Press disclaim all liability in connection with the use of this book.

All rights reserved. No part of this book may be reproduced or transmitted in any form whatsoever without prior written permission from the publisher except in the case of brief quotations embodied in critical articles and reviews.

Dedicated to Fred "Crosby" Grant, South St. Paul artist, photographer, historian and really great guy.

Contents

Acknowledgements and Contributing Authors 9
Introduction 13

1. Indians, Missionaries and Settlers Arrive 17
2. Business, Politics and Passions 25
3. The Smell of Money 41
4. They Came to Work 53
5. South St. Paul Women 65
6. Neighborhood Memories 73
7. The End of an Era 107
8. Reclaiming the River 129
9. Gangsters, Governors, Flames and Foot Longs 145
10. Before and After Images 155

Afterword 163
Bibliography 165
Index 167
About the Author 175

Acknowledgements and Contributing Authors

Nick Ferraro, a reporter with the *Saint Paul Pioneer Press*, received an e-mail from The History Press in 2013, asking him if he'd be interested in writing a book about Pill Hill in South St. Paul, Minnesota. Nick was bemused because he isn't a historian and had simply written a story about Pill Hill based on information that I'd sent him in a press release about a history tour of the area that was being hosted by South St. Paul Restorative Justice. He forwarded the e-mail to me, and I quickly replied. The History Press responded that, although our little Pill Hill was not what they had in mind, they were very interested in our surprisingly unique community and asked me to consider producing this new history.

I jumped at the chance. South St. Paul has changed a great deal since a 528-page history with over one thousand photographs was published for the city's centennial in March 1987. As this current project progressed, I relied on a variety of new sources. One of the most significant is the Facebook page called "Conversations of History in South St. Paul," started by Adrian Aguirre and Heather Lomax in July 2014. Hundreds of contributors have posted photographs, memories and opinions about South St. Paul from all over the world and provided me with insight into not only history of long-gone days but also that of more recent years.

I could never have completed this book without the cooperation and support of the Dakota County Historical Society. Its vast photography collection was opened to me, and librarian Rebecca Snyder was always helpful and creative in finding source material and providing me with digital photographs for the publication.

Acknowledgements and Contributing Authors

I continue to owe a huge debt of gratitude to the South St. Paul Chapter of the Dakota County Historical Society which hired me as the editor and designer of the 1987 centennial history of South St. Paul. Those faithful volunteers, many of whom are no longer with us, worked for years in the 1980s to collect interesting, colorful and informative articles and photographs in anticipation of publishing a city history. The book went into five printings of one thousand copies each and, although now out of print, copies occasionally become available online for several times the initial price of twenty-five dollars.

I also thank David Mather, National Registrar archaeologist at the Minnesota Historical Society, for his advice concerning the burial mound discussion. Michele Decker, with the State Historic Preservation Office, generously provided me with copies of the applications for South St. Paul's three structures that are on the National Register of Historic Places. I also appreciate the time that Branna Lindell and Edie Kleinbohl spent with me at the South St. Paul Housing and Redevelopment Authority offices and for their many answers to my questions over the past few months. South St. Paul city clerk Christy Wilcox provided me with information on elections and mayor/council terms, and Community Affairs liaison Deb Griffith obtained the mayor photographs and responded quickly to all of my questions. City engineer John Sachi was extremely helpful in providing dates for road changes and major city projects, and Parks and Recreation director Chris Esser was always helpful. Kelton Glewwe assisted with some tricky scanning situations, and Lisa Brandecker and Samantha Chin provided historical photographs of several of South St. Paul's schools. Photographers Linda Dietsch, Fred Grant and Kelly Rae Vo gave me excellent images for this history, and I am filled with gratitude for Renee Werner Ponto and her brother, Richard Werner, for allowing me to use the amazing images that their father, Reinhold O. Werner, both restored and created over the years. I am also appreciative of Tim Spitzack, editor and publisher of the *South St. Paul Voice* newspaper. He has given me the privilege of writing a monthly history column for the past eleven years and approved my use of the articles I've submitted as the basis for some of the information in this new history of the city.

Oh, and Nick, thanks for forwarding that e-mail.

Acknowledgements and Contributing Authors

Contributing Authors

Sharon Nechville Olson (page 77): I have lived in Eagan for almost fifty years, but I still have wonderful memories of growing up in South St. Paul. I moved around a little after leaving home—to Washington, D.C., and Chicago—but Minnesota has always owned my heart. Eventually, I came back. I've been retired from the political and law office work I did for some time now and am enjoying life with my husband, Dean, and our dogs and cat. We still go back to South St. Paul to pick up chicken at the Coop!

Sue Oestreich Grove (page 81): I have lived in Austin, Minnesota, since 1975. I am an emeritus faculty member, retired from teaching French, English, ESL and speech at Riverland Community College in Austin. My husband, Vern, and I have one son, Chris; one daughter-in-law, Alicia; and two grandchildren, Jacob and Madi. I am on several boards: Friends of the Austin Public Library, Austin Symphony, Episcopal Church Council, Mower County Historical Society and Minnesota Association of Library Friends. I have wonderful memories of growing up in South St. Paul. My brother still lives in the house we grew up in.

Jim Servatius (pages 85 and 107): I was raised on South Concord Street in my early years, but our family moved up on the hill to Ninth Avenue North in 1954. I worked in the auto repair business in South St. Paul before going to 3M Company in 1966. I retired from 3M in 2001 after thirty-five years and haven't slowed down since, as I stay very busy with my many hobbies. My most cherished moments are spent with our two children and four grandchildren, who, fortunately, live close by.

Kevin K. Holtorf (page 94): I still live in South St. Paul, going on fifty plus years now. I am retired from Northwest Airlines, after being injured there, but still work a part-time job. My life, my pride and joy, are my two children, Joshua and Jenna, whom I love dearly. I have always referred to South St. Paul from the lyrics of one the Eagles songs. South St. Paul is like the Hotel California: "You can check out any time you like, but you can never leave." I don't see myself leaving; this was a great place to raise my children. My future will be somehow giving back to this great community with the small town feel.

Acknowledgements and Contributing Authors

Kristin Machacek Leary (page 100): Upon graduating from South St. Paul High School in 1987, I went on to Concordia College in Moorhead, Minnesota, where I received bachelor's degrees in organizational communications and English. After living in many different cities across the United States, my husband, Tim, and I currently reside in Southern California, where I am an executive at a global medical device company. I consider myself fortunate to have been raised in South St. Paul for the strong foundation it provided for my life.

Paul O'Brien (page 130): I've been in St. Cloud, Minnesota, since 1990, and remained here after I graduated from St. Cloud State University. I travel North America installing controls and automation equipment in industrial laundries and have gotten to fish many places that I would never have otherwise. I still live only a short bike ride from the shores of the Mississippi and still fish it on occasion, although things like fires and BB guns are frowned on here in town.

Introduction

The Coop Restaurant in South St. Paul, Minnesota, is a neighborhood eat-in/take-out place that has been offering up fried chicken, ribs, fries, Coneys and burgers since November 1963. There's a big bulletin board next to the counter that has the usual advertisements, pictures of lost dogs and cats, notes about apartments for rent and other vital information. There is also a stack of handouts tacked in one corner so that people can help themselves to a copy. It's entitled "We know you're from South St. Paul if…" and lists the following criteria:

- Your parents had the same teachers you did
- You know what the GFN and PNA stand for
- You know someone who hangs out at the Cro
- In high school, you visited places called the Flats, Property and Crick
- You know all sixteen-plus names the "Channel House" has had
- You have attended the state hockey tournament twenty-five times or more
- You know Herb, Whitey and Walt
- Stockmen's at 2:00 a.m. for breakfast is on your agenda
- You can recall the wooden playground at Central Square
- "5th Avenue Plaza" was considered a shopping mall to you
- You remember walking in the tunnel under Nineteenth Avenue in Kaposia Park
- Three generations of your family graduated from South St. Paul High School

Introduction

- You take offense when someone refers to South St. Paul as St. Paul
- You know where Pitt Street is
- You can properly pronounce words like Kaposia, Wakota and Glewwe
- At your class reunion, you see all of your neighbors
- You've been to a wedding reception at the Cro, Polish Hall or Serbian Hall
- You can fondly recall the Bon-Ton (meet me at the Bon-Ton)
- You know the difference between the Co-op and the Coop
- You didn't think it was odd that the gas stations were called "Bunny's," "Nipp's" or "John's"
- Winds from the east, and the subsequent odor, did not bother you
- You know why our high school teams are called the Packers
- You can recall having two Glewwe's grocery stores
- You can name the five grade schools that once existed
- You know someone who knew when the John Dillinger gang was in town
- You bought your clothes from Mary Adams, Gerkovich's or Jean Iverson
- You lived in town before the floodwall was built
- Your family bought a car on Concord Street and furniture at the Grand Mill

 It's fun to watch people pick up a copy and start to laugh and read each statement aloud to a friend as they reminisce and argue and kid each other about this town we call home. There are a couple other versions of the list that appear periodically on Facebook. No one seems to be the author; the ideas just flow free out of the air and onto the list. What seems like a sort of silly insider joke really is, however, a pretty accurate overview of South St. Paul and the unique characteristics that make it a special place.

 This brief history is an attempt to tell South St. Paul's story to a new generation of residents, many of whom cannot recall the days when traffic on Concord Street was bumper to bumper nearly twenty-four hours a day and when the stockyards, the packing plants and the related industries employed over twelve thousand people. They don't remember how the smell of manure from the yards, the stench of the rendering plants and the odor of the sewage from the adjacent Metropolitan Waste Control plant caused the rest of the Twin Cities metropolitan area to make fun

Introduction

of "Cowtown" and the bars, gambling and Wild West characters who populated our streets. They probably have no knowledge of the devastating floods that occurred each spring before the Mississippi River was tamed along our shores.

It's time to tell our story again.

1
Indians, Missionaries and Settlers Arrive

The story of South St. Paul begins 1,500 to 2,000 years ago when nomadic bands of American Indians identified the Mississippi River and the steep, craggy bluffs on its western bank as a sacred space. It isn't possible to specifically identify these early groups as direct ancestors of today's Dakota people, but we do know that the land where the city of South St. Paul was built remained an honored site to the Dakota for generations. The earliest people created massive burial mounds, where their dead were interred, along the bluffs above the river. These ancient mounds extended from Annapolis to South Street with the largest mounds clustered in the Bryant Avenue area to Summit and extending to the bluffs of what is now Kaposia Park. Another massive mound area covered the center of town where today's Dakota County Historical Society, library and city halls were built. A series of smaller mounds were created atop the hills leading all the way to the city's southern border.

During the centuries prior to 1800, the only visitors to the site were fur traders, explorers and bands of Mdewakanton Dakota Indians who had gradually moved south from the area around Mille Lacs.

For the nomadic Mdewakanton, the construction of Fort Snelling by the federal government in 1819 brought enhanced trading opportunities, offering a permanent location from which to trade their furs in exchange for guns, metal pots, cooking utensils, woolen blankets, beads and clothing. By the end of the 1820s, one of the bands of the Mdewakanton Dakota, known as the Kaposia, settled in what may have been their earliest permanent village.

The word *Kaposia* has no direct translation into English but characterizes the quick-moving agility of the people in their skill at playing lacrosse and also evokes their general nature as a nomadic people.

The Village of Kaposia

Mdewakanton Dakota chief Wakinyantanka, known in English as Big Thunder, was chief of the Kaposia band when they settled in what is now South St. Paul. They had previously lived on both sides of the river to the north near the current city of St. Paul, determining their location by the level of the river flooding in the spring. Wakinyantanka was the fourth in a line of hereditary chiefs who were called Little Crow by the French traders.

The first whites to arrive at Kaposia were the Methodist missionaries, led by Reverend Alfred Brunson, who arrived at the village early in 1837. Brunson brought Reverend David King along as teacher and John Holton and his family, who were to support the mission by farming. Also in the group was James Thompson, an enslaved man who was married to a Dakota woman. Brunson raised $1,200 to buy Thompson's freedom, and Thompson became the interpreter for the new mission. David King began to study the Dakota language, and by July 1837, the missionaries had built a schoolhouse, mission building and trading store on the site, which was approximately at what today is known as the Simon's Ravine trailhead south of Butler Avenue on Concord Street. That same year, 1837, Wakinyantanka was taken to Washington, D.C., as part of the delegation of Dakota chiefs who were being courted to sell all of their land east of the Mississippi River to the federal government. The treaty was signed on September 29, 1837, opening up the land across the river from the Kaposia village to white settlers.

It wasn't long before those white settlers began to encroach on the land on the west side of the Mississippi, causing trouble with the Kaposia. Brunson had to return East because of illness, and Reverend Benjamin Kavanaugh was sent to Kaposia to take his place. Unfortunately, some misunderstanding occurred between Wakinyantanka and Kavanaugh, resulting in Kavanaugh moving his family across the river to Red Rock in what is now Newport, Minnesota. He supervised the mission from there. By 1843, Wakinyantanka had withdrawn his support, and the Methodist mission school was closed that year.

A Brief History

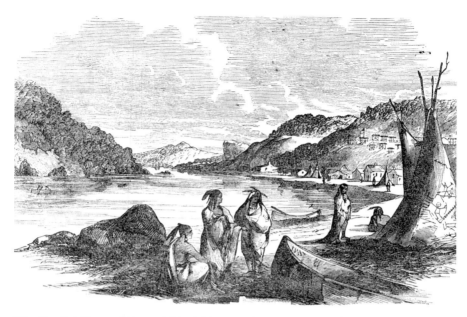

The *New York Illustrated News* published this engraving of Little Crow's Kaposia Village on the Mississippi River in 1852. Today, the site is the Simon's Ravine Trailhead south of Butler Avenue on Concord Street. *Dakota County Historical Society.*

Two years later, in October 1845, Wakinyantanka was shot while following the wagon his wife was driving up what we know today as the Bryant Avenue hill. A gun that was placed in the bed of the wagon started to slide off the back. Wakinyantanka grabbed the gun to stop it from falling, and it went off, severely wounding the chief. Before he died, he informed his people that he had named his son, Taoyateduta, also known as His Red Nation or Little Crow V, to be the new chief.

Taoyateduta was an unlikely choice. His mother had left Wakinyantanka when Taoyateduta was a young boy and had taken him back to her own people at the Wahpeton Dakota settlement at Lac qui Parle, Minnesota, where he grew up. He attended the Presbyterian mission school there under its founder, Reverend Dr. Thomas S. Williamson, and learned to read and write in the Dakota language and to understand arithmetic. Wakinyantanka had several other sons by his various wives, many of whom lived at Kaposia. The appointment of Taoyateduta as Little Crow V was not what they had planned. When Taoyateduta arrived at Kaposia in the spring of 1846 to claim his position as the new chief, two of his brothers shot him as he left

his boat, shattering his forearms. Taoyateduta was taken to the Fort Snelling physician, who wanted to amputate his hands and forearms, but the chief stopped the doctor, refusing to face life without the ability to hold a weapon or hunt to support his family. He survived, but his hands and wrists were deformed for the remainder of his days.

The two brothers who had led the attack on Taoyateduta were killed by the new chief's supporters, and Little Crow V established himself as leader of the Kaposia band. One of the first things he did was inquire of the local Indian agent whether he could send them a missionary to open a school. Thomas Williamson, Little Crow's former teacher from Lac qui Parle, agreed to accept the invitation and arrived at Kaposia with his wife and children and his sister, Jane Williamson, in October 1846. The Williamsons were Presbyterians who worked for the American Board of Commissioners for Foreign Missions. They had been at Lac qui Parle since 1835, and Thomas and Jane were fluent in the Dakota language. Thomas had already translated several books of the Bible into the Dakota language, and Jane often taught her students to read and write in Dakota by translating the old hymns of the Presbyterian Church into their language and having the students sing. The Dakota called Jane by the Dakota name Dowandutawin, or Red Song Woman, in honor of her beautiful singing voice.

By now the Kaposia village had become a hub of activity with many dignitaries, tourists, military personnel and government officials visiting throughout the year. Steamboats from the east docked at the riverfront, and the travelers often stayed with the Williamsons, who had built a large, gracious home on the site. St. Paul was rapidly growing into what would become the state capital, and Fort Snelling continued to be the center of government activity for the area. In addition to the mission school, the federal government opened a school at Kaposia, first led by Sylvester Cook and then by Reverend John Aiton, who arrived with his wife, Nancy, in 1848.

Dakota County was established on October 27, 1849, and it wasn't long before the federal government acted on the desire to open even more land for white settlement. In two treaties, signed at Traverse des Sioux and Mendota in 1851, the Dakota sold all of their land on the west side of the Mississippi River to the government, which promised to establish the Dakota on two new reservations in western Minnesota. For the first time in thousands of years, the sacred hills that had been the site of burial mounds and villages for the ancient people and then for the Dakota would no longer be Indian land.

The Williamsons left for their new mission near Granite Falls, Minnesota, in the fall of 1852, and the Dakota gradually made their way to the new

Upper and Lower Sioux Reservations by 1854. Kaposia meanwhile, was a hotbed of real estate activity. There were only three established villages in Dakota County at the time: Hastings, Mendota and Kaposia. The first official meeting of the Dakota County commissioners was held in John Aiton's house at Kaposia on July 4, 1853, and Kaposia was named the county seat, a designation it held until Mendota was selected in October 1854. Hastings took over the honor on March 17, 1857, and has held that designation ever since. John Aiton was named the postmaster for the federal post office at Kaposia when it opened on February 4, 1853, and remained in that role until the county seat was moved to Mendota.

Several names were suggested for the Kaposia site during these years of organizing the government. On March 29, 1853, in a letter he wrote to Jane Williamson, now in the Williamson manuscript collection at the Minnesota Historical Society, early settler Andrew Robertson suggested St. Andrew's as the name in honor of his own contributions to the area. Jane suggested that "Kaposia, Dakotaville, or something to continue the memory of the poor Indian" would be more appropriate. It was not until May 11, 1858, that the Dakota County commissioners met and changed the name of Kaposia to West St. Paul. It was the day that Minnesota became a state, and they felt that their efforts to attract white settlers would be hampered by retaining the Dakota name while identifying the area with the new state of Minnesota's capital city of St. Paul would draw much more interest and attention.

Creating a New Town

Like many others, Jane Williamson assumed that the village would be divided into plats and sold off to create a new city. She held on to her portion of the mission property until Franklin Steele, Governor Henry Sibley's brother-in-law, paid her $3,000 in 1854 to abandon her claim. Others immediately jumped on the property and Steele, who did not make the required improvements to the land which would have allowed him to hold the property, had his claim preempted by a man named John Coulter. Years of legal battles ensued until Addis Messenger and Sherwood Hough achieved a patent for the site in November 1856. They laid out a pie-shaped town site with its long side on the river divided into forty-two blocks, each measuring 50 by 150 feet. Five streets were platted running east and west.

Several lots were sold and efforts made at improving the site. The challenge, however, was the land itself.

While the Dakota had been flexible enough to withstand the impact of the rising river every spring, the village site was basically a flood plain for the Mississippi. No one could deny that attempting to construct permanent roads and houses on the wetland was a challenge. That same flood plain location meant that anyone who desired to farm in the area had to expand their land holdings to the bluffs high above the river. The Dakota had always used the flatter land at the top of the bluffs for their own harvest. In addition to the bluffs and the ravines that slashed through the woodlands, settlers had to contend with the fact that the top of the bluffs were covered with the extensive series of ancient burial mounds that extended the entire length of the village and beyond.

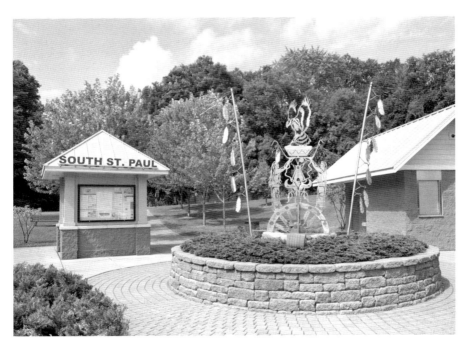

This sculpture, designed and cast by Ojibwe artists David Estrada and Bill LaDeaux, was dedicated on the site of the former Kaposia village on June 23, 2007. Commissioned by the River Environmental Action Project (REAP), the sculpture honors all of the Kaposia chiefs Little Crow and their families. The thirty-eight feathers commemorate the thirty-eight Dakota hanged in the largest mass execution in the United States in Mankato, Minnesota, on December 26, 1862. Engraved paver blocks—donated by families, organizations and businesses—mark the trailhead leading to Kaposia Park. *Kelly Rae Vo, photographer.*

A Brief History

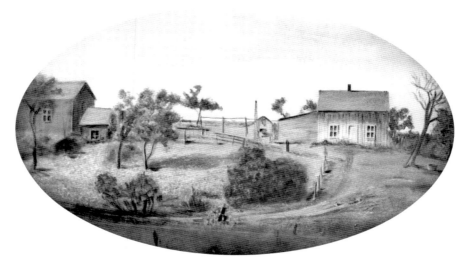

Emilie Hartnagel was just one year old when her parents established their farm on what is now the 100 block of Eleventh Avenue North in 1853. She married Josiah Kocher in about 1868, and they took over the farm, raising their own family. This painting, by an unknown artist, portrays the Kocher homestead. *Reinhold O. Werner Photo Collection.*

Ultimately, the location of the Kaposia village simply was not practical for residential development. The mission buildings were gradually removed or demolished, and Mrs. Addis Messenger, who was the last to own the platted settlement, deeded the site to the public in 1888.

While the county leaders were concentrating their attention on the three main population centers of Dakota County—Mendota, West St. Paul and Hastings—hundreds of settlers continued to move into the area, file claims and purchase property. The majority were farmers from the eastern states who were anxious to establish successful agricultural operations on the virgin land. In the new West St. Paul Township, which encompassed all of today's cities of West St. Paul and South St. Paul, the best farmland was on the western side of the township in what is now the city of West St. Paul. Huge 260-acre plats were broken, plowed and planted by the enterprising new settlers. The eastern half of the new township was more of a challenge. Even the land above the river on the bluffs was often rocky and hilly, divided every mile or so by deep dramatic ravines that channeled water to the Mississippi River below.

For the most part, the east side of West St. Paul Township along the river was a quiet, sleepy place where travelers could pass through on the road

from St. Paul to Hastings without seeing a single person. Riverboats no longer stopped at the Kaposia site but headed for the capital port of St. Paul. Small groups of Dakota would occasionally show up at the old village and settle in for a few weeks but they were legally confined to the reservations and would soon make their way west again. It was not until 1884 that things began to change.

2

Business, Politics and Passions

S t. Paul railroad magnate Alpheus Beede Stickney, founder of the Chicago Great Western Railway, turned his professional attention to the riverfront land along the Mississippi in West St. Paul Township in 1884. Through his work in Chicago, Kansas City and Omaha, Stickney had come to realize that cattle growers in the west were having difficulty getting their livestock to the meatpacking plants in Chicago. Driving the animals overland was becoming more difficult as cities were established on the western plains. Cattle lost a significant amount of weight on the journey and many animals died. Alpheus believed that shipping cattle by rail would be more efficient, but he also recognized that the animals needed a place to be rested, fed, watered and fattened up before getting to Chicago. He began to search for an expanse of land where he could hold hundreds of cattle for this holding period, and he came across the river flats along the eastern border of West St. Paul Township.

His first challenge was to extend his tracks through the area to Hastings, Minnesota, and then on to Chicago. Construction started at St. Paul in September 1884, and a year later the line was open to the Iowa state line. Stickney acquired and merged with smaller lines along the way to Illinois in order to complete the connection. Building the new route through the riverfront area of West St. Paul Township required dealing with the annual spring flooding of the river. Stickney hired workers to move thousands of tons of dirt from the sides of the steep river bluffs and haul it to the riverfront to raise the level of the land by more than four feet, eventually filling in

260 acres of riverfront in order to create the platform that would ultimately become one of the largest stockyards in the world. The St. Paul Union Stockyards Company was incorporated on June 30, 1886, by Stickney and Constantine W. Benson, the head of C.W. Benson and Company, a St. Paul investment firm.

In 1886, Stickney commissioned St. Paul architect C.A. Reed to design a headquarters for the new business. It was an impressive and massive structure that continues to dominate the northeast corner of Grand Avenue and Concord Exchange today. The first load of cattle arrived at Stickney's new stockyards on September 30, 1887. By then, entrepreneurial investors had begun to build brick storefronts and wooden boardinghouses along the old dirt roadway known as the St. Paul and Hastings Road. Despite the ravaged bluffs that had been demolished to raise the level of the land along the river, people were attracted to Stickney's new operation and cattle brokers began to arrive in town from Chicago and St. Joseph, Illinois, ready to try their luck in this new stockyards operation.

Alpheus Stickney was the founder of the St. Paul Union Stockyards Company, which opened in 1886 in the area that became South St. Paul. *City of South St. Paul.*

Another St. Paul entrepreneur, Charles Wilbur Clark, was a real estate investor in the 1880s. He founded an investment firm with his cousin, Arthur E. Clark, and the two had joined with John H. Bryant by 1884, forming the Clark-Bryant Improvement Company. They learned of Alpheus Stickney's plans to expand his railroad on the eastern border of West St. Paul Township and saw an opportunity to build their own business. By the end of 1886, they owned 280 acres of farmland, extending from the river to what is now Nineteenth Avenue North between Wentworth and Butler Avenues. Stickney purchased the land for his railroad tracks from the Clark-Bryant Company and Clark in turn began attracting major manufacturing firms to the area, offering them land for one dollar in exchange for their investment in building new plants and factories along the river. The Warner and Hough Machine Company, the Holland and Thompson Manufacturing Company and the Dwane Iron Works were among those who relocated to the area. One of the most significant newcomers that Clark brought

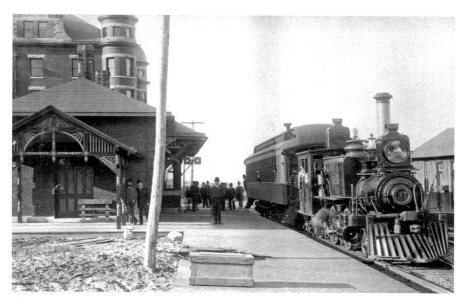

Above: Stickney brought the railroad to town in 1884. The original depot, pictured here, was relocated to the north side of the Exchange Building in 1914. *Dakota County Historical Society.*

Below: The Stockyards Exchange Building was constructed on the northeast corner of Grand Avenue and Concord Street in 1886. Hundreds of livestock-related industries had offices in the building over the years. The Exchange is on the National Register of Historic Places and today is a catering and wedding venue. *Dakota County Historical Society.*

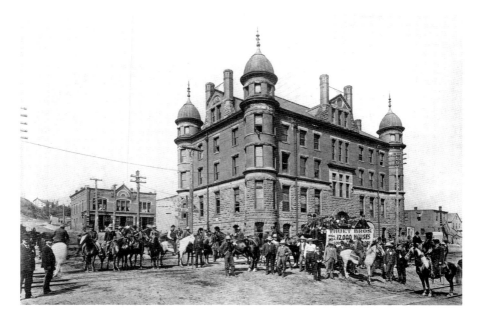

Charles Clark, a real estate investor from St. Paul, established the community of South Park on Bryant Avenue and Concord Street in 1886. He brought several major industries to town, including Waterous Engine Works, which still has its international headquarters in South St. Paul. *Author's collection.*

to town was Waterous Engine Works Company then headquartered in Brantford, Ontario, Canada.

Charles Clark married St. Paul socialite Emma Day on December 8, 1885. The couple lived on Ashland Avenue in St. Paul a few doors down from Clark's friend famed St. Paul architect Cass Gilbert. In 1886, Clark and Bryant commissioned Gilbert to design the impressive hub of the new city that they were creating. Known as the Bryant Block, the building was on the northwest corner of Bryant Avenue and Concord Street. The structure directly on the corner was built as a grocery store and Charles Clark recruited another cousin, Arthur D.S. Clark, to give up his grocery in Barry, Minnesota, and relocate to this area, which Clark named South Park, after South Park, Illinois, where his wife's family originated. The second building in the block was also designed as commercial or retail space and the third was a magnificent civic building with a ballroom on the third floor and meeting rooms and offices on the main and second floors. It was known as the Ten-O-Nine Hall at 1009 Concord Street.

Dozens of other entrepreneurs began to build on every available piece of land as workers poured into the area, and hardware stores, groceries, butcher shops, restaurants, bars, pool halls, gambling joints, bakeries, tailors, barbershops, clothing stores and shoe shops soon lined the streets. There were no zoning codes in those early days, and a shop could appear almost overnight in the back of another shop along the street. Rocky, zigzag paths connected the enterprises and the population of the new city continued to increase, reaching 2,242 by 1890.

All of this energetic growth along the riverfront led to some grumbling among the elected officials of West St. Paul Township that was still the governing body overseeing the area. Clark and Stickney and others were eager to promote their new city to investors from out east, and they felt that the farmers in the western half of the township were not as progressive or

A Brief History

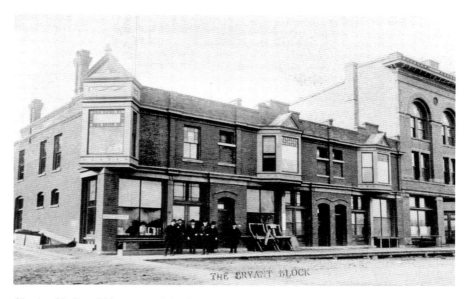

Charles Clark and his partner, John Bryant, commissioned famous St. Paul architect Cass Gilbert to design the Bryant Block on the northwest corner of Bryant Avenue and Concord Street in 1886. The three-story building on the right is the only portion of the original structure that remains in 2015. *Dakota County Historical Society.*

creative as their colleagues and friends in the new community along the river. It is intriguing to imagine the heated discussions that took place at township board meetings as the representatives from the burgeoning new city on the river confronted the isolated landowners in the western half of the township. The farmers wanted to benefit from the possibility of tax revenue from the new businesses, but they never hid their suspicions and concerns about the outside investments that were pouring into their historic township.

South St. Paul Becomes a City

In January 1887, a delegation representing the industrialists and livestock men from the riverfront businesses was able to organize and write a new charter for a new city that they wanted to call South St. Paul. Why South St. Paul? One of the reasons for the proposed name change was that West St. Paul was and always had been confusing for mapmakers, travelers and potential new residents. There was, after all, the first city of West St. Paul

that was incorporated in 1858 as the northernmost portion of West St. Paul Township. It was a separate entity until 1874, when it was turned over to West St. Paul Township. Today, that old city is loosely contiguous with what current residents call the "West Side" of St. Paul. To complicate matters, the old city of West St. Paul was always part of Ramsey County, while West St. Paul Township was part of Dakota County. On top of those confusing designations, the land called West St. Paul wasn't west of St. Paul; it was south. Thus, the new city of South St. Paul was born.

The Minnesota legislature approved the new charter, which was voted and accepted on March 2, 1887. The newly elected officials for the first city of South St. Paul held their first meeting on March 5, 1887, at the McClung School near George Wentworth's red brick mansion that still stands today on Wentworth and Oakdale Avenues in today's city of West St. Paul.

A few weeks later, on April 23, 1887, the new city officials borrowed their first $5,000 to meet general expenditures. The challenges were great for these newly elected leaders. Their constituents included the wealthy upper-class bankers and commission men of Clark's South Park, the railroad investors and livestock executives of Stickney's industry, the laborers pouring into town from across the country looking for work and the old pioneer farmers of the lands to the west who had no intention of giving up their agricultural way of life. South St. Paul was born out of a precarious political partnership that would continue to mark its progress for years to come.

The South Park Monorail

One of South St. Paul's most famous claims is that it is the first city outside of New York to have its very own electric monorail. Charles Clark, like many of his late 1880s colleagues, was a man filled with ideas for how to improve the quality of life and increase financial prosperity for all. The city of New York had unveiled the first monorail in America in 1875. Suspended above the Manhattan streets, the "El," as it came to be known, marked an entirely new way of transportation for American cities.

The St. Paul City Council was approached by several developers who were interested in creating a monorail system that would connect St. Paul not only to Minneapolis, but to new cities like South St. Paul, which was attracting workers from all over the Twin Cities. On June 1, 1887, Charles Clark and a group of other investors, including his cousin, Arthur D.S. Clark, of the

A Brief History

Clark & Company Grocery Store, received approval to create the South St. Paul Rapid Transit Elevated Railway Company to provide a street railway in the city. The monorail, as it was called, was so named because it ran on a single electrified rail which controlled a suspended passenger car. It was to provide transportation from St. Paul to the river industrial area in South Park, connecting with Stickney's rail operations into St. Paul and Hastings.

Clark and his partners closed a deal with the Daft Electrical Company of New York in June 1887 and named the new venture the Enos Railway Company. Several other companies were also meeting with the St. Paul City Council to present their own proposals, but the Enos Company was the only one that constructed a working model of a monorail that people could experience in person. The footings for the massive structure were eight feet deep. The posts themselves were twelve to fifteen feet high and supported a framework at the top that was about ten to twelve feet across. A single rail was installed at the top and above it were the electric wires that furnished power for the passenger car. The car itself hung underneath the trestle a few feet above the ground. It would run in one direction on one side of the rail and return in the other direction. Clark and his colleagues

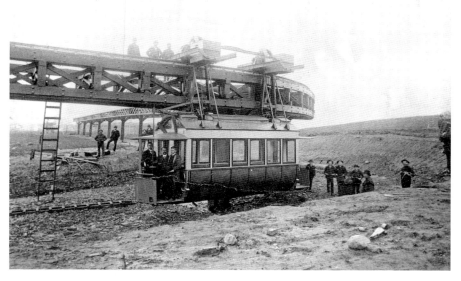

On May 9, 1888, Charles Clark debuted his electric monorail, which traveled westward up the Bryant Avenue Hill to Sixteenth Avenue North. It was intended to carry passengers from the bluff neighborhoods down to Concord Street and connect to the main railroad, which would take them to St. Paul or Hastings. *Dakota County Historical Society.*

built just one elegantly appointed passenger car with seats upholstered in plush blue velvet. They also built only a partial track that went up the Bryant Avenue Hill to Sixteenth Avenue North and then turned to the south for about a half mile.

On May 9, 1888, over two hundred dignitaries from across the United States and Canada were invited to South Park to participate in the formal debut of the monorail. The visitors caught the train at the foot of Jackson Street in St. Paul and disembarked on the platform across Concord Street from the Bryant Avenue Hill, then known as Allison Avenue. The Enos Railway station was on the corner, and South St. Paul mayor Joseph Lawrence gave an eloquent speech welcoming the visitors to the city. The first brave volunteers soon stepped forward, and the passenger car began its climb up the hill, a route deliberately chosen to demonstrate that the system would work even on a steep incline. The inaugural ride successfully transported twenty-seven passengers at a speed of approximately fifteen miles per hour, with the first group embarking at 1:00 p.m. After all had had an opportunity to ride the monorail, the visitors were welcomed to a luncheon at the Ten-O-Nine Hall ballroom, where they listened to a variety of speeches by visiting executives and company representatives.

The *Saint Paul Pioneer Press* of May 10, 1888, described the excursion as a complete success and noted that visitors were welcome to come to South Park any day to try the ride for themselves. Several successful trips were made over the course of the next few days, according to subsequent news articles in the *Saint Paul Pioneer Press*, from May 12 to 15, 1888. Along with the glowing reports of the monorail itself, however, the paper also reported the ongoing arguments at St. Paul City Hall. Many business owners and residents along the proposed connection of the monorail to St. Paul objected strongly to the system crossing their frontage access. As of May 26, 1888, the council still had no recommendation to make. With city elections approaching, the Enos Company decided to delay their petition until possible new councilmembers had taken their seats. The protests did not stop after the elections, however, and when the council convened on June 30, 1888, residents and business owners again stormed the meeting to protest the construction.

Over the course of the next few weeks, the Enos Company was successful in moving its proposal forward, but although the council finally granted the company permission to enter the city limits of St. Paul, it refused access to the city limits of Minneapolis at its borders. The overall result was that neither the Enos Company nor any of its competitors received permission from the City of St. Paul to operate an electric monorail in the city. It was

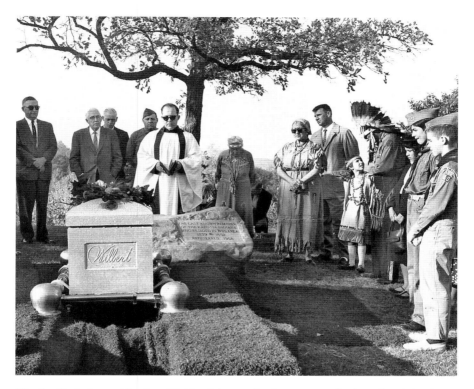

Charles Clark donated land on Highland Avenue for the purpose of reinterring skeletal remains of American Indians as they were unearthed during excavation of the burial mounds for various building projects, including his famous monorail. On October 12, 1958, recently found remains were reinterred and several descendants of Little Crow V participated in the ceremony. Those identified in the photograph include Joseph Klectatsky (first from left); Fred Lawshe (second from left); Reverend Richard K. Smith (fifth from left); Little Crow's granddaughter Morning Star (seventh from left); her husband, Scarlet Boy (ninth from left); and Little Crow's great-great-granddaughter Winona (eighth from left). A stone marker identifies the sacred site in 2015. *Richard Werner, photographer.*

to be another 125 years before St. Paul or Minneapolis saw the successful implementation of today's light rail system.

The visionary dream of South St. Paul's monorail came to a sad and sorry end. The city engineer ordered the company to remove its station at the foot of Bryant Avenue and to demolish the tracks. The little passenger car reportedly sat on the side of the hill until it was finally removed in 1918. For decades to come, excavators working in the gravel pits along the south side of Bryant Avenue would often call the local newspaper to report that they'd dug up another piece of the famous monorail.

Charles Clark was heavily invested in the electric railway and its demise was a financial tragedy for him. He was also recovering from a personal tragedy. Only a month before the debut trip of the monorail, Charles Clark's wife, Emma, died in childbirth. The child did not survive. It was Clark's involvement with the new industries he and John Bryant had brought to South Park that made it possible for him to work toward financial recovery.

While Alpheus Stickney and Charles Clark were focusing their business acumen on expanding their own holdings in the new city of South St. Paul, the city councilmembers continued to argue about priorities and expenditures. One of the most significant disagreements concerned where the city hall would be built. George Wentworth offered to donate land on his property on Oakdale and Wentworth if the city would build a structure for no less than $6,000. Other investors also stepped forward and said they would donate for the new building if it was completed in less than a year and came in under $6,000. Some on the city council, however, dragged their feet on accepting any of the proposals. Not surprisingly, they were men whose interests and investments were in the eastern portion of the city along the river. They wanted the new city hall built on their side of town, not out in the country to the west.

The council did manage to successfully grant thirteen liquor licenses in its first ten months of existence and passed its very first ordinance creating the South St. Paul Police Department. It issued $20,000 in bonds of $1,000 each at 6 percent interest to finance the construction of new school buildings and hire teachers. In the summer and fall of 1887, several disgruntled government appointees either resigned or were suddenly replaced, usually by men whose allegiance was to the stockyards industry. Then, in the 1888 elections, all but two of the councilmembers from the western farmlands were defeated by representatives from the eastern half of the city. The final straw was that city clerk Noah Groff, who was married to Susan Wille, the daughter of one of the western farmlands most prominent leaders, was defeated by William Bircher of South Park in the eastern portion of the city.

West St. Paul Walks Out

The councilmen from the western part of the city had had enough and on February 22, 1889, they met on their own and privately implemented plans to reclaim their community and create a new city of West St. Paul.

A Brief History

The Minnesota state legislature approved their petition on February 28, 1889. South St. Paul was basically cut in half with everything west of the old German Road, today's Oakdale, turned over to the new city of West St. Paul. South St. Paul, now greatly reduced in size, also lost five of the nine school buildings that had been built since 1887.

Politically, the new, smaller city of South St. Paul was also divided. Several councilmembers had gone with the West St. Paul contingent so elections needed to be held immediately and an entirely new slate of officers took over. Then the battle between the two cities really took off. South St. Paul filed an injunction against the new West St. Paul forbidding the Dakota County treasurer to release any funds to West St. Paul unless West St. Paul agreed to resolve $14,000 in disputed bonds. No settlement could be negotiated and South St. Paul now faced a definite school crisis. The school known as Riverside on Concord Street was already overcrowded as was the new Lincoln that had been built on the northeast corner of Fifteenth and Bryant Avenues. Stickney School in the center of town was also filled to capacity.

In March 1889, the South St. Paul Council decided it had to move forward and issued $85,000 in bonds to provide school, fire department and city hall funding. On May 6, 1889, it also resolved that a city hall be built as quickly as possible and that it be located at the fork in the road where Grand Avenue

The first South St. Paul City Hall opened at the top of the Grand Avenue hill at Third Avenue North in July 1890. It was demolished and replaced with the current municipal building in 1956. *Author's collection.*

met Third Avenue North. According to the South St. Paul City Council minutes of May 6, 1889, architect John H. Coxhead submitted plans for the building, which were accepted, and Barnett & Record were hired as contactors to handle construction. The completed city hall was accepted on July 28, 1890. Just as Stickney's Exchange Building was considered by some to be an unnecessary extravagance, the dramatic city hall, with its elegant tower and elaborate façade, was felt to be a terrible waste of money. It dominated the Grand Avenue hill, exuding the power of the new city's leaders, who were pleased to announce on August 11, 1890, that they had finally settled the $14,000 bond discrepancy with West St. Paul, which had agreed to pay that amount into South St. Paul's coffers. The new city had resolved the immediate financial crisis and erected a magnificent center of government. The future appeared bright.

St. Paul Tries to Annex SSP

Unfortunately, South St. Paul was on the verge of yet another crisis. First of all, when the city council convened in 1889, it discovered that some $1,700 was missing from the accounts that had been under the supervision of the former city treasurer, Marcus Lienau. Then, in January 1891, a new newspaper in town, the *South St. Paul Reporter*, founded by Arthur D. Moe and W.H. Dunne, began to print rumors concerning the extravagant spending of the common council, as the city council was known. On February 9, 1891, Charles H. Lienau, brother of the accused former official and a Minnesota state senator from St. Paul, wrote a letter to Dakota County senator Ignatius Donnelly and itemized his complaints against the elected councilmembers. The letter was published word for word in the *Reporter*.

Lienau accused the council of squandering over $100,000 in less than a year and a half, with unpaid bills pending all over the area. He claimed there was almost nothing to show for these expenditures. His letter continued:

> *They* [the property owners living in South St. Paul] *will tell you some strange stories about the building of a so-called "City Hall" at an enormous cost, a building for which there was absolutely no demand; about the purchasing of three steam fire engines* [from one of the aldermen] *which are simply stored away because of the lack of water; about enormous printing bills paid to the man who is doing financiering for the corporation…*

> *allowing an alderman $8,500 for a rickety frame hotel building and then selling the same back to him for $800.*

The accusations continued, and Lienau told the senator, "The real people of South St. Paul have expressed a desire that the municipal jurisdiction of the city of St. Paul be extended over their territory." Lienau described how much better off the citizens of South St. Paul would be if they were residents of St. Paul and encouraged Donnelly to carry forward his request.

Senator Donnelly responded that he would certainly favor the proposal as long as Ramsey County didn't assume that it would take over the portion of Dakota County that was South St. Paul but that it would just be a transfer of governance to the city of St. Paul. Even South St. Paul's own mayor at the time, W. Denney, who was superintendent of Stickney's Stockyards Company, told a local reporter on February 4, 1891, that he thought South St. Paul would benefit from becoming part of St. Paul and that he "hoped the two cities will soon become one."

Donnelly called a meeting for the night of January 28, 1891, at the Merchants Hotel in St. Paul, and three men from South St. Paul were selected to start circulating petitions in favor of the annexation proposal to South St. Paul residents. Marcus Lienau, the disgruntled former city treasurer, was one. Paul Suskie, a shoemaker from the south end of the city was named, as was John Kochendorfer, a surprising choice since he was one of South St. Paul's earliest residents and a prominent land owner on the north end of town. On January 31, 1891, the three had gathered more than one hundred signatures within the first forty-eight hours of circulating the petition. That night, Frederick Waterous, chairman of the Board of Trade, presided over the public meeting to discuss the proposal. A blizzard had begun in the afternoon and reportedly caused smaller attendance than expected but the arguments were loud and angry.

Then Charles Fitch, the first commission man in the city, took the floor:

> *Are there not other citizens of this city besides the property owners to which Mr. Lienau refers? Men who live here, have families here, and add to the material wealth of the city? They too are entitled to much consideration. The majority of property owners are non-residents and speculators. When they have sold their lots they are through with the town. Down here in the Exchange I'll show you men that have an interest in this town…The syndicates and big concerns signed this petition because they might have to pay some taxes.*

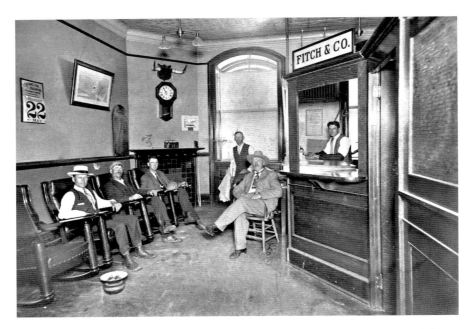

Charles Fitch, seated in the center wearing the light-colored suit, slept on the floor of the new Stockyards Exchange Building when he arrived in town in 1887 with his brother Allen. They opened one of the first commission firms in the exchange, and it was Charles Fitch's powerful oratory that helped prevent the annexation of South St. Paul by St. Paul in 1891. *Reinhold O. Werner photograph collection.*

John Simon told the group that the effort was more spite work than anything else. "We got the stockyards without St. Paul; they wouldn't have them within their city limits." Fitch joined in once again, "St. Paul men are apathetic about the stockyards industry; they have no sympathy with us. We had better stay outside and attend to our own business."

The meeting adjourned without any recommendations being approved, and over the next two weeks, both sides of the issue exchanged barbs in the local paper while the council and the board of trade considered options. Then, on February 26, 1891, the *Reporter* noted that, "The movement toward extending the municipal jurisdiction of St. Paul over this city is ended. Friends of annexation admitted yesterday that Senator Donnelly found so much opposition to the measure in Dakota County that he would not favor it."

It is perhaps no surprise that the elections of July 1891 brought another whole group of leaders into elected office. By this time, the city hall had

been outfitted with steam heating and an artesian well had been dug to provide water to the building. Its rooms and auditorium were rented nearly every night for literary readings, socials, church meetings and civic group gatherings. Its construction cost had prompted criticism and controversy, but for the next sixty-plus years, it would be the focal point for the growing community. Those who held office there kept the city together through two world wars, Prohibition, the Great Depression and labor union strikes. In its first five years of existence, the city had been rocked to its very foundations from within and without. Now it was time to prepare for a new century. Still, Charles Fitch's words continued to echo over every development effort the city made, as civic leaders took his advice to heart: "We had better stay outside and tend to our own business."

3

The Smell of Money

What is it like to grow up and live in a stockyards town? Today's South St. Paul residents really have nowhere to go to capture the experience of growing up in a city whose identity, atmosphere, economy, entertainment and ambience revolved around a massive single industry like meatpacking. From September 30, 1887, when the first trainload of cattle arrived in the new St. Paul Union Stockyards from Montana, until the spring of 2015, when the last commercial meatpacker closed, South St. Paul and meatpacking were synonymous.

Known as "the yards," the massive 260-acre stockyards property that Alpheus Stickney and his partners developed in 1886 was a vast complex of pens filled with cattle, sheep and hogs; weigh stations; office buildings; slaughterhouses; mechanical shops; veterinarian offices; meat inspection facilities; the auction barn; overhead walkways; railroad tracks; refrigeration cars; vehicle parking; employee cafeterias; medical and welfare offices; and, through the years, acres of covered or open pens extending as far as the eye could see.

From the very beginning, Alpheus Stickney's investors were concerned that the operation would offend nearby residents because of the odor. Stickney assured them that the strong northwesterly winds would prevent any offensive odors from reaching the town. Anyone who ever lived, worked or traveled through South St. Paul knows that wasn't true. The smell of manure from the yards hit like a wall when one entered the town from any direction, especially as one crossed the bridge over the Mississippi River

South St. Paul

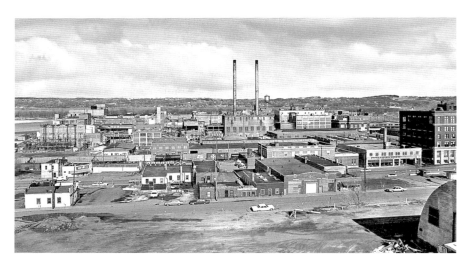

The massive stockyards extended from Concord Street on the west to the river on the east and from Wentworth Avenue on the north to Highway I-494 on the south. *Fred Grant, photographer.*

heading into the city, where the scent from the yards combined with the odors from the Metropolitan Waste Management facility, the tannery and the rendering plants to create an unforgettable olfactory sensation, especially during warm summer months.

Still, South St. Paulites soon learned to call that odor "the smell of money." The stockyards and related businesses were the economic, social and cultural heart of the community, and with thousands of people employed in that industry, people were grateful for the jobs, the excellent schools and the vast array of businesses and services that were available in the city because of the livestock industry's civic involvement and financial support. Even when outsiders from the greater metropolitan area made fun of the smell and looked down on South St. Paul as a rough, lawless, ramshackle town, residents defended the city and proved the city's success in its high school hockey, football, basketball and other sports, as well as by winning national awards in speech and debate tournaments, in its civic accomplishments, through its economic security and with its consistently strong employment. There was a comradery that grew among those who worked together in the massive plants. Although workers came from all over Europe and included middle-class whites as well as minority populations from across the Twin Cities, the shared experiences of killing thousands of animals a day in unbelievably bleak conditions, butchering all kinds and cuts of meat and

A Brief History

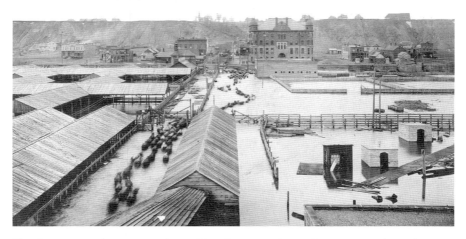

Flooding every spring was a major problem for the stockyards from the time the business opened in 1886 until the flood wall was finally constructed in 1965. This photograph, taken in May 1897, shows the cattle being driven to higher ground. *Dakota County Historical Society.*

salvaging intestines for sausage casings and organs for sweetbreads brought people together in a bond of loyalty and defensive pride. Of course, along with the slaughter operations, others worked in canning, curing, packaging, shipping and the many offices, where plant executives, salesmen, advertising staff and stenographers kept the operations running smoothly. Still others managed food service at the plant cafeterias while additional personnel were on site to provide medical care or welfare assistance to workers.

Beyond the meatpacking plants were the related industries, including the commission firms, banks, insurance companies, investment brokers and livestock growers, whose offices were in the Exchange Building. Dozens of yardmen worked the pens around the clock, logging animals in as they arrived by train or truck from out west, manning the scale houses where livestock was weighed, connecting with buyers from the packing plants as deals were cut and prices negotiated. When the auction barn became the main source of sales activity, additional workers became part of that system. It is estimated that by the mid-1950s, more than twelve thousand people worked in South St. Paul in some aspect of the livestock industry and related businesses.

SOUTH ST. PAUL

THE PACKERS ARRIVE

Alpheus Stickney's initial vision was more focused on bringing success to his railroad investments than on meatpacking. The stockyards were to be a holdover spot where livestock growers could feed their stock and fatten them up before shipping them to Chicago, where the nation's meatpacking companies were centered. It wasn't long before Stickney's investors began to surmise that they'd be making a lot more money if they could process the animals right in South St. Paul and not simply provide livestock for Chicago's packing plants.

By January 1888, the South St. Paul branch of the international Anglo-American Packing and Provision Company opened a modest slaughterhouse in the yards. That operation was followed by the Minnesota Packing and Provision Company, with expanded slaughter operations. In 1896, Stickney and his investors began negotiations with Chicago's Swift & Company and made them a deal they couldn't refuse. They offered the entire Minnesota Packing and Provision Company facilities to Swift's on a 999-year lease and agreed to give the company common stock and the buildings on the leased property, as well as the payment of a yardage fee for any cattle received. In October 1897, Joseph Bangs and Wallace Gebhart were sent up to South St. Paul from Swift's in Chicago to begin construction of Swift & Company's new meatpacking facility in South St. Paul.

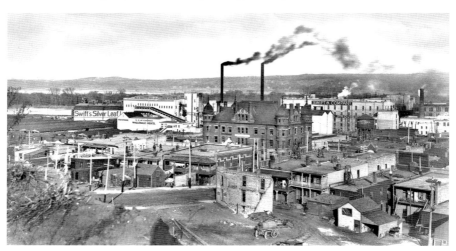

Swift & Company opened the first major meatpacking plant in South St. Paul in 1897. At its peak production period in the 1940s and 1950s, the plant sometimes employed as many as six thousand people. It closed in 1969. *Dakota County Historical Society.*

A Brief History

The arrival of Swift's truly meant the survival of Stickney's stockyards. Within two years of the Chicago company's establishment in the South St. Paul yards, the number of cattle kills increased by 76 percent and hog kill was up by more than 48,000. By 1907, when Swift's local operation was ten years old, 141,103 cattle were killed and 793,328 hogs, marking a gain of 801 percent in cattle and 918 percent in hogs from 1897.

Perhaps the most significant difference that Swift's arrival made, however, was in how South St. Paul's culture changed. Both Joseph Bangs and Wallace Gebhart took active leadership roles in the community, and although Bangs retired to Florida after working in South St. Paul for more than thirty years, Wallace Gebhart lived in town for the rest of his life. He and his wife, Susie Zahnen Gebhart, raised their family in the community. His descendants include the Metzen and Kaliszewski families, both well known for years of public service to the city.

Another way in which Swift & Company's arrival marked a significant change in the local meatpacking industry was that the opening of an actual slaughterhouse operation required hundreds of new workers and young men and women began arriving in town from all over the country seeking employment. Word soon spread to Europe where Swift's actively recruited workers with promises of a great new life in America and hopeful immigrants headed for the city from Romania, Poland, Hungary, Serbia, Croatia, Ireland and other Eastern and central European countries. The influx resulted in a boom in building along Concord Street as boardinghouses sprang up to accommodate the new workers. Many were informally segregated by county of origin so that the individual ethnic groups could find others who spoke their language and shared their experience of coming to America.

It is remarkable to note that between 1900 and 1910, South St. Paul's population increased by 94.2 percent, from 2,322 to 4,510. As early as 1897, Armour & Company, the other major meatpacking plant in the country, put a regular buyer in the South St. Paul market. In 1906, Armour's received several invitations to open a packing plant in New Brighton, Minnesota, but the residents there protested the idea. General Mark D. Flowers, head of the South St. Paul stockyards, offered Armour's $1 million in shares of common stock and $500,000 in bonds, plus twenty acres of land in the yards, but Armour's expressed no interest in the proposal.

Then on July 28, 1914, World War I broke out in Europe, and although America under President Woodrow Wilson remained officially neutral, it soon became clear that this war might require American intervention. The U.S. government was not accustomed to providing food for servicemen

South St. Paul

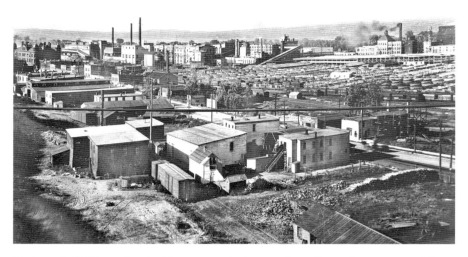

By the early 1900s, workers had begun to arrive in town from all over the country and from Eastern and central Europe. Boardinghouses sprang up overnight to accommodate them. *Reinhold O. Werner photograph collection.*

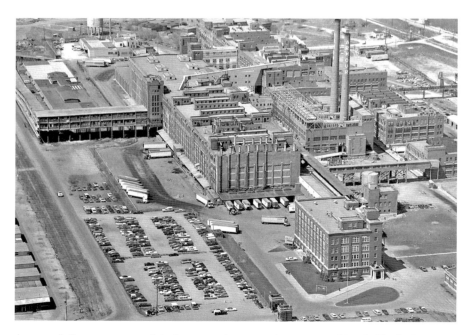

Armour & Company opened the largest and most modern meatpacking facility in the world in the South St. Paul yards on December 26, 1919. The company employed over six thousand people during its peak years of the 1940s to 1950s. The plant closed in July 1979. *Fred Grant, photographer.*

halfway around the world and companies like Armour's were offered federal subsidies if they would expand operations in anticipation of needing to feed the troops abroad. This time Armour & Company took the bait and began building a massive new packing plant in the South St. Paul yards in 1915. The facility was advertised as the most modern plant of the day, and it dominated the riverfront south of the Swift & Company plant when it opened in December 1919.

The post–World War I years were a boom in the local industry. Between 1910 and 1930, the number of residents increased from 4,510 to 10,009. Concord Street was lined on both sides with dozens of businesses, and cattle, sheep and hogs continued to arrive in the yards every day. Alpheus Stickney didn't live to see the stockyards he'd founded become one of the largest livestock centers in the world. He died on August 9, 1916, at the age of seventy-six. Charles Clark of South Park took office as mayor of the city in 1911 and served three terms. He remarried in 1893 to a childhood friend, Lucy Larcom Spaulding, and they had a daughter, Emilie, in 1895. Unfortunately, Clark suffered yet another loss when Lucy died just six years later. He and his little daughter, Emilie, remained in the city that he had helped build. Charles Clark passed away in 1931 at age seventy-seven.

A New Postwar World

When America entered World War II after the bombing of Pearl Harbor on December 7, 1941, South St. Paul was caught up in the patriotism and passion that the entire country experienced. The city at the time had a population of nearly twelve thousand. The livestock industry had helped the community survive Prohibition and the Great Depression and the plants were operating with full shifts by 1940. Seventy-five commission firms, meatpackers, cattle companies and related firms were operating in the South St. Paul market. The war brought massive changes to the community and ultimately to the livestock industry itself.

The sight of new military inductees boarding busses outside South St. Paul City Hall became a common occurrence. Women poured into the slaughterhouses to take the men's places on the lines. Before long, the plants were operating twenty-four hours a day, six days a week, in order to provide troops with protein products like Swift & Company's Prem, a canned meat product that rivaled Hormel's Spam. By 1946, the 200

millionth head of livestock had moved through the local stockyards. It would be impossible to overestimate South St. Paul's contribution to the war effort. With the most modern packing plant in the world in operation locally, more shipments of meat and meat products were sent to the battlefront from South St. Paul than from any other location. South St. Paul protein literally kept the troops alive.

Everyone on the homefront began energetic conservation efforts by not driving in order to conserve gas; growing vegetables in victory gardens; living with rationing of products like sugar, butter and coffee; and collecting tin cans, metal, tires and milk weed to create kapok, which was used in life preservers. War bond drives brought movie stars like Ingrid Bergman to town, and a huge billboard on top of the Grand Avenue hill recorded the names of every South St. Paul soldier who was serving the country.

The war came to an end in Europe on V-E Day, May 8, 1945, and ended worldwide with the August 1945 atomic bombings of Hiroshima and Nagasaki, leading to the surrender of Japan on September 2, 1945. Within weeks, servicemen began returning home to South St. Paul. As they arrived, it soon became clear that for many men, the war had changed their expectations of the future. Those who had worked for pennies an hour on the slaughterhouse floor had often fought side by side with management administrators in the trenches. They were no longer content to resume their former status as low-paid labor but were looking for advancement and increased wages. At the same time, the women who had been earning a living and supporting the family while the men were gone were not always eager to give up those positions just because the men were back. Tensions grew within the livestock industry and the unions as both sides tried to adapt to new expectations.

THE 1948 STRIKE AND MEMORIAL DAY FIRE

By March 1948, tensions within the local market led the workers at three main packing plants—Swift's, Armour's and Rifkin's—to go on strike. Picket lines formed that succeeded in suspending operations at the plants. Dakota County sheriff Norm Dieter and local police chief Louis Fuller were turned back from enforcing an injunction against the strikers on March 22, and by the end of the month, several picketing cases were in court in Hastings. Early in April, the sheriff was barred from the lines again, following the arrest

of Milton Siegel, field representative of United Packinghouse Workers. By April 13, Swift & Company had succeeded in running two delivery trucks, escorted by Sheriff Dieter and local police, from the company's plant through the picket lines at Grand Avenue and Concord Street.

Tensions mounted in the following days, and violence erupted on May 12, 1948, when strikers completely closed the livestock market and lined up by the hundreds to prevent non-union workers from entering the plants. Disobeying injunctions limiting the pickets to ten, the picketers tipped over cars and pistol shots were fired over the heads of strikers. When strikers were denied unemployment compensation by the St. Paul Union Stockyards Company on May 13, thousands jammed the intersection of Grand and Concord and repulsed officers in a move that led to a free-for-all battle between strikers and police. On Friday May 14, Minnesota governor Luther Youngdahl authorized the state adjutant general to mobilize the National Guard to put an end to the violence.

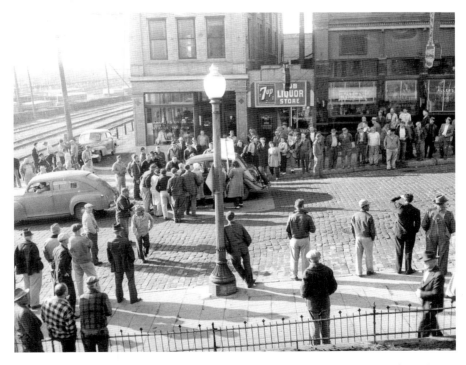

The 1948 United Packinghouse Workers strike lasted sixty-seven days and shut down the South St. Paul market. Crowds gathered in the street every day to prevent workers from crossing picket lines until Governor Luther Youngdahl sent in National Guard tanks, which came rolling down the Grand Avenue hill to break the strike lines. *Dakota County Historical Society.*

South St. Paul

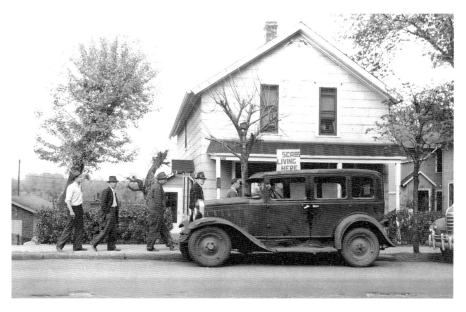

The strike split families and friendships, and some homes were marked with signage indicating, "Scabs Living Here." Workers ultimately settled for a nine-cent-an-hour raise. *Dakota County Historical Society.*

On Saturday morning, four hundred men of the National Guard assembled against a crowd of one thousand picketers. With bayonets fixed and backed by military tanks, the troops spread across the entire width of the intersection and moved forward slowly. As the crowd fell back, it dispersed without incident, and the permitted number of strikers took up their posts. The Guard pulled out a week later, on May 22, 1948, when the strikers were directed by union officials to agree to a nine-cent-an-hour raise, as opposed to the twenty cents they had originally requested.

The 1948 strike culminated fifteen years of initial organization attempts by the national union, the United Packinghouse Workers of America. The national union had been formed on October 18, 1943, and by 1946, following the increased production years of the war, requests for wage increases closed 134 plants. The strike in South St. Paul in 1948 brought changes for both sides of the industry, but the dark days of the local action tore the town apart for months and years to come.

Just a few days after the strike came to an end, on Memorial Day 1948, the largest fire South St. Paul ever experienced broke out in the yards at about 1:15 a.m. Smoke columns rose quickly from the tinderbox of pens.

A Brief History

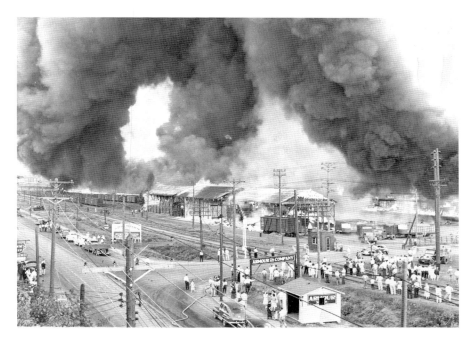

Less than a week after the strike came to an end, fire broke out in the yards on Memorial Day 1948. No one was killed; however, several head of cattle were lost, and over $2 million of damage was caused to the stockyards. The fire did not spread to either of the major packing plants. Many residents remember the sky filling with thick black smoke on that holiday weekend. *Dakota County Historical Society.*

The fire could be seen for fifteen miles as the black smoke swirled through the entire area. Family picnics were forgotten as area residents climbed the banks of the hills above Concord Street to watch in fascination and fear as the fire spread through the yards. St. Paul fire companies were called in, and it took nine pumpers and 206 men two days to extinguish the blaze. Miraculously no lives were lost, but the devastating damage included several head of cattle and over $2 million in estimated losses.

Although the timing of the 1948 fire led to accusations that disgruntled workers had turned to arson in revenge, nothing was ever proven, and no cause of the fire ever determined. The yards were rebuilt, and as the American economy continued to grow in the early 1950s, the plants once again operated at full capacity while the city continued to grow. By 1950, the population of South St. Paul had increased to 15,909, and residential housing construction was booming. It appeared that the community had survived the war and was entering the 1950s full of optimism.

4
They Came to Work

One of the greatest impacts the establishment and growth of the stockyards had on South St. Paul was the huge number of people who came to the city from Europe to work in the packing plant industry. Both Swift's and Armour's placed advertisements with newspapers in foreign countries and even sent recruiters to Europe to solicit new workers. Fourteen carloads of immigrants pulled into the Concord Street depot nearly every morning in the early years of the 1900s. It is difficult to imagine what it was like to get off that train at the South St. Paul Depot by the Exchange Building. In winter, the icy cold winds would blow across the river to chill the bones of weary travelers. In the dense and humid heat of summer, the smell of manure, and the heavy odors of the rendering plant and tannery must have provided quite a welcome. No matter what the time of year, stretching out before them were the acres and acres of pens full of animals headed for the slaughterhouses. Often a crowd would gather at the station to await the arrival of relatives from back home or just to see who was in this latest group of newcomers. Women and children, along with their goats and chickens, were herded to one side while the men were immediately recruited for work as the packing plant supervisors picked their new crews.

No matter where they ended up sleeping in those early days, the reason people put up with the inconvenience, the smells, the overcrowding and the uncertainty was because there were jobs for anyone willing to work. Laboring in the stockyards was backbreaking physical work. Lifting and hauling sides of beef and skinning, boning and washing the carcasses was possibly one of

the hardest jobs a man could choose. The killing floor was a grisly bloodbath of slaughter where operating a too-quick knife often resulted in the loss of many fingers. Interviewed by their grandson, Mike Belisle, in 1986 for the South St. Paul Centennial History book, Iris and Cecil Lawrence reflected on their memories of working at Armour's:

> *The worst job was the killing floor. We had two kinds of kills: pig and cattle. The pig killers would stand in a small room with their huge butcher knives and let one pig in at a time, hang it by its hind legs, cut its throat and throw it on the belt. The cattle killers stood above a doorway and when a cow was let through they smashed it on the head with a sledge hammer. We could hear the huge pigs and cows hit the floor after being slaughtered.*
>
> *There was so much blood on the floor up in those rooms that workers would get hurt from slipping. They would put salt on all the floors so people wouldn't slip, and it would burn our feet right through our shoes.*
>
> *There was another bad job. It was called the offal room. They had to clean out all the pig intestines for sausage wrappings.*

No matter how brutal the conditions, working in the industry created a bond that brought people of different nationalities together because of their shared experiences. Some were in town temporarily, enticed by the promise of earning more money in the packing plants in a year than they could back home. They were men who left their families in Europe, worked in South St. Paul for a relatively short period of time and then returned home with their savings. The majority of the new arrivals, however, had left their homeland behind forever and wanted to learn to speak English, to get their children into school and to become U.S. citizens. Despite the desire to fully participate in American life, there was also a need and preference to keep alive the cultural traditions, religion, food and customs of their birth country. Four major ethnic groups were established and continue to maintain a physical presence in South St. Paul today.

The Polish Zagloba Society and Holy Trinity Catholic Church and School

By 1905, the South St. Paul census reported forty-two persons of Polish descent living in the city. The Polish National Alliance of North America

A Brief History

had been founded in the United States early in the 1900s, and in January 1909, the local Polish community met to form their own affiliated society in South St. Paul. Twenty-five persons attended the first meeting at Frank Lencowski's house on First Avenue South. They chose the name Zagloba, after a mythical hero of Poland, and by 1916, the group incorporated as Lodge No. 1033 of the Polish National Alliance.

In the summer of 1911, the group constructed its first meeting hall at 622 First Avenue South. The building was remodeled in 1919, and an addition was built in 1935. In 1952, a ladies' lounge was added. The hall became a meeting place for the society but it was also a gathering place for the Polish workers from the stockyards. The bar and restaurant were open every night and on weekends, and families met there to discuss news from home or talk about future plans. Membership was open to anyone of Polish or Slavic descent and their spouses.

In addition to enjoying one another's company, the Polish community wanted to establish their own Catholic parish and began to discuss the feasibility of creating their own church even before the First World War began in 1914. The war brought an end to further church planning until October 1919, when Reverend Father Peter Roy, the pastor of St. Adalbert's Parish in St. Paul, came to South St. Paul to meet with the society's leadership. The group chose the name Holy Trinity, and sixty families pledged their support of the new church and purchased the site

The original Polish Hall was built in 1911 and additions and renovations were made through the 1950s. The society decided to take down the social hall and construct two apartments on the property. The bar and restaurant in the lower level is still open at 622 First Avenue South in 2015. *Dakota County Historical Society.*

for a building on Sixth Avenue South. They incorporated in 1924, but it was several years before they raised enough money to break ground for Holy Trinity Catholic Church on November 13, 1940. The parochial school at Holy Trinity opened in September 1954 for grades one through eight with an enrollment of 243 students. Kindergarten was added in 1984 and a preschool program began in 1988 for children ages three, four and five. In 2015, Holy Trinity is the only parochial school still operating in the city.

In 1962, the society's main hall was torn down and replaced with two one-bedroom apartments. The members still operate a bar and restaurant in the lower level of the new building and carry on the traditions of their Polish ancestors to the present day.

St. Sava Serbian Benevolent Society

One of the most significant immigrant groups to arrive in South St. Paul was from Serbia. They held their first meeting to talk about forming a society in 1909 and founded the St. Sava Benevolent Society with thirty-one charter members, eventually becoming a sub-assembly, Lodge Number 47, of the Serb National Federation. The members met in people's homes for the first few years but were able to begin construction of the Serbian Home at 404 Third Avenue South in 1923. The hall was a gathering place for the community members, and wedding receptions, anniversaries, birthdays and other celebrations were commemorated there. The Serbian community made a point of keeping their language alive by having classes for children and preserved their musical heritage through the Tamburitza Orchestra, which provided entertainment for weddings and parties all over the metropolitan area.

The hall has a ticket booth inside the front door that led to a large wooden dance floor and stage. Lawrence Welk and popular Polka bands like Whoopee John performed there in the 1930s. The kitchen and dining area was in the basement with a forty-five-foot-long wooden bar.

Most of the Serbian community worshipped at the Russian-Serbian Orthodox Church in St. Paul until forming their own congregation in 1950. They erected a temporary chapel on the upper floor of the Serbian Hall until the actual church building at 357 Second Avenue South was erected in 1951. The church split ten years later and participation and

A Brief History

Today, the Serbian Home on the southwest corner of Fourth Avenue and Third Street South is a museum and research center operated by longtime local historian Ted Trkla. The building was added to the National Register of Historic Places in 1993. *Dakota County Historical Society.*

funding support for the Serbian Home began to decline. The hall's liquor license was revoked in 1964, when renewal papers were not filed in time, and in 1969, the property was rezoned as residential, meaning that no liquor license could be re-issued and the building could not be used for public purposes.

Fortunately, Ted Trkla, whose father came to work in South St. Paul in 1906, worked tirelessly to not only save the hall from demolition but also formed the Serbian Cultural and History Center. In 1993, Trkla and others led the charge to have the hall placed on the National Register of Historic Places, and Trkla serves as curator of the Serbian art and history collection, which is housed in the building. In 2007, when the building was threatened with closure due to lack of funds, a private citizen loaned the center money to buy the building and make improvements, including a new roof and furnace. Trkla recently purchased the property behind the center in hopes of converting some of it into a parking lot so that the cultural center can legally open as a public museum.

Hrvatski Dom Croatian Association

Perhaps the most well-known ethnic people to settle in South St. Paul were the Croatians. Several families had arrived in the city before and during World War I, and they gathered informally in one another's homes until 1918, when they established an active chapter of the Croatian Fraternal Union with a membership of between sixty and seventy families. Known as Lodge Number 129 out of Illinois and named the Hrvatski Dom Association, members began construction of the Croatian Hall at 445 Second Avenue South in 1919. Croatian was spoken in the lodge, and Sunday concerts and other performances and plays were the center of entertainment for the Croatian families in the city.

Most of the local members were Roman Catholics and attended worship at St. Augustine's, Holy Trinity or other area parishes. The local Croatian Association is one of the largest in the United States and frequently hosts national conventions and events. Several South St. Paul organizations meet at the hall regularly, including the South St. Paul Jaycees, and politicians of all stripes often hold their election night victory or loss parties at the basement bar. Dozens of South St. Paul graduating classes hold their class reunions at "The Cro," as it is known locally, and Sarma Dinners, with both eat-in and take-out cabbage rolls, continue to draw huge crowds.

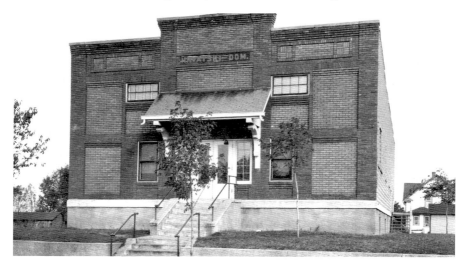

The Croatian Hall was opened at 445 Second Avenue South in 1919. It continues to provide social and meeting space with a bar and restaurant for Croatians and others from all over the Twin Cities. This photograph shows the original hall before the many renovations and additions of recent years. *Author's collection.*

A Brief History

St. Stefan Romanian Orthodox Church

It was 1904 when the first Romanian immigrants arrived in South St. Paul. There were twelve men, mostly single, who left their wives and children behind with plans to make money and return home. Over the next twenty years, the Romanian community swelled even though a majority of immigrants returned to Romania after World War I. While St. Mary's Romanian Orthodox Church has existed in St. Paul since 1913, the Romanians who made South St. Paul their home wanted their own church. On August 15, 1922, the Clubul National Roman (Romanian National Club) was incorporated in the state of Minnesota under its first president, Nicholas Choban. The club initiated the establishment of a parish and organized "Parohia Rom. Ort. St. Pr. Ilie," or Romanian Orthodox Parish of Patron Saint Ilie (Elijah), later changed to St. Stefan Romanian Orthodox Church. The congregation first met on February 12, 1923, at 265 North Concord Street in the upstairs of a boardinghouse owned by George and Eva Albu.

Property was purchased at 350 Fifth Avenue North on June 12, 1923. The City of South St. Paul donated another half lot to the congregation. The new church building—designed by Emil Neagoe, a nephew of Nicholas Bretoi, one of the parish's founding fathers—was constructed by local builder John Bartl and was dedicated on September 24, 1924. Stefan Doichita donated a sum of money with the request that the parish be named St. Stefan.

Through the years, the church has been served by the Ladies' Auxiliary, and Romanian School was held for many years on Saturdays with religious instruction and Romanian-language classes for children. In 1921, a group of Romanians decided to found the protestant Christian Apostolic Church. Gary Rosenberger posted on Conversations of History in South St. Paul on Facebook on September 1, 2015, that he had interviewed Eva Musta in 1984 and she told him her husband, George, built the Christian Apostolic Church next to his house but on the same lot at 127 Tenth Avenue North. It was a building about the size of a single car garage and was set back about ten feet from the sidewalk. The members had met in two prior locations before moving into the Tenth Avenue location. About 1949, with the building's roof leaking and the members holding umbrellas inside, it was decided they would build a new church on Seventh Avenue North, and they hired a contractor to build that church, which is still standing at 129 Seventh Avenue North today, although the congregation disbanded in the 1980s.

Although St. Stefan was never the kind of social club that the Polish, Serbian and Croatian Halls were, the church did provide amazing

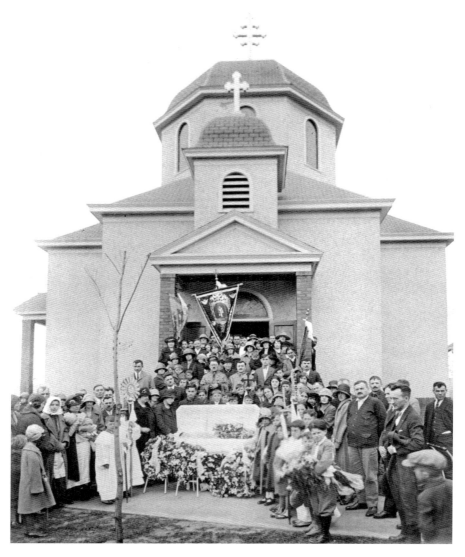

St. Stefan Romanian Orthodox Church was placed on the National Register of Historic Places in 2004. This photograph was taken at the funeral service for seven-year-old Aurel Barsan, who died in 1925 after drinking some kind of poison found in a discarded bottle behind the tavern his father ran with Nicholas Bretoi. *Author's collection.*

A Brief History

Romanian feasts to the community in its tiny basement hall. For many years, Eli Motu and his wife, Ella Choban Motu, participated in community activities and always welcomed civic groups to meet at the church or to come for excellent meals provided by the Ladies' Auxiliary. Reverend Motu assisted many Romanian immigrants who came to the Twin Cities during the cold war years. Their son, Nick Motu, served on the South St. Paul City Council and spearheaded the effort in 2004 to have St. Stefan placed on the National Register of Historic Places. Today, the charming Byzantine-style church continues to overlook the Mississippi River on Fifth Avenue North at Grandview Park in South St. Paul.

AMERICANIZATION DINNER

Central School Fri. Evening April 9, 1920 5:30 to 8 P. M.

Meats and Fish
Baked white fish with dressing....15 cents
Salmon Loaf......................10 cents
2 Wienerwurst....................5 cents
Then there will be two Barbecued pigs - chicken - turkey - tenderloin and ham at reasonable prices.

Salads
Fruit, vegetables, salmon, shrimp 10 cents
Potato salad.....................5 cents
Buttered Buns....................2 cents
Homemade cakes-piece.............5 cents
Homemade pies-per cut............5 cents
Coffee-cocoa-tea-per cup.........5 cents

Specialties
Flat Bread, Leftse, Scones, Struddle, Chop Suey, Spanish Rice, Spaghetti Italieene, Fattigmand, Cheese all kinds, and other delicacies of foreign countries at reasonable prices.

COME, FEAST, BE MERRY

Benefit Central Playground

The community welcomed newcomers from Europe and many gained U.S. citizenship through the Americanization program at South St. Paul High School. This menu from a celebration dinner in April 1920 reflects the desire to offer truly international options. *Minnesota Historical Society.*

Becoming a U.S. Citizen

By the end of World War I in 1918, South St. Paul was truly a city of immigrants. The schools were overcrowded and bustling with the most recent arrivals who had poured into town from all over Europe. The children did not speak English and were unfamiliar with the patterns and priorities of public school. Teachers had to adjust and adapt to teaching children a new language while also instructing them in reading, writing and arithmetic. The students themselves had the encouragement of their parents, who were also struggling to learn English and become American citizens. Supported financially by the St. Paul Union Stockyards Company, South St. Paul High School began to hold night school classes that not only taught adults the English language but also helped them achieve their high school equivalency degrees and their American citizenship. By 1922, twenty-one nationalities were represented in the night school classes.

Every spring there was an Americanization Dinner, prepared by the domestic science class for the graduates, and all of those who had become citizens were honored at this dinner. Businesses, churches and civic organizations provided significant support to the Americanization Council. The awarding of citizenship was a very special event when, with pageantry and celebration, each class was honored for their achievement. In one such program in March 1931, the general managers of Swift's and Armour's were both on the program. The Romanian Choir and Serbian Singers joined the Mexican Orchestra and the Croatian Orchestra on stage. A German-Swiss yodeler and an Irish lassie performed, as well as Bohemian dancers, a German trio and a Polish singer.

Our Melting Pot Mentality

Over the years, many people have spoken with me about what it was like to grow up in a city with the kind of diversity that South St. Paul has had since it was created in 1887. Names like Vujovich, Voynovich, Dragich, Crnobrna, Tomovich, Bogatich, Bretoi, Matczynski, Koich, Kronovich, Milosevich, Marschinke, Trkla, Bogatich, Woog, Matras, Palodichuk, Funari, Lulic, Popovich, Rogowski, Badalich, Kosowski, Banaszewski, Wisniewski, Pietruszewski, Kaliszewski, Sokolowski, Roszak, Lencowski, Mankowski, Drkula, Doichita, Chalupa, Choban, Albu, Perkovich, Sobaski, Sobaszkiewicz, Vaidich, Jerikovsky, Sarafolean and many other unusual names roll easily off longtime residents' tongues since they're our relatives or we've gone to school with classmates with those names for years. Even today, the scholarship list published each May by the South St. Paul Educational Foundation continues to reflect the ethnic origins of South St. Paul's population, as do the rosters of sports teams and civic committees.

The community's acceptance of these arrivals from Europe was encouraged by the school district, and hundreds of earlier immigrants from Germany, Ireland and Scandinavia worked side by side on those bloody slaughterhouse floors with these new neighbors. No doubt there were occasional neighborhood conflicts or problems, but the European immigrants were white; as long as a person was white, they were accepted and welcomed into the community. Even during the conflicts in Bosnia and the Balkans in the 1980s, the Croatians, Serbians and Romanians in town always got along.

A Brief History

Despite the community's diversity, African Americans and Latinos were not welcome in South St. Paul. They were allowed to work in the packing plants without a problem but could not live or own property in the city. New residential developers presented potential buyers with the following covenant, which was required in several neighborhoods, including on Park Lane: "No person of any race, other than the Caucasian race, shall use or occupy any dwelling on any lot, except that this covenant shall not prevent occupancy by domestic servants of a different race or nationality employed by an owner or tenant." The provision is dated October 23, 1940, and it was reportedly included in purchase agreements for properties across the city in these years before the Civil Rights Act of 1964. South St. Paul was not the only community to require such covenants, which can be found all over the country.

There was one African American resident who was allowed to live in the city as long as he slept in the jail at city hall. Charles Verdier came to town with the Ringling Brothers Circus in 1923, but when the circus moved on, he remained behind. The South St. Paul Police found him in a snowbank,

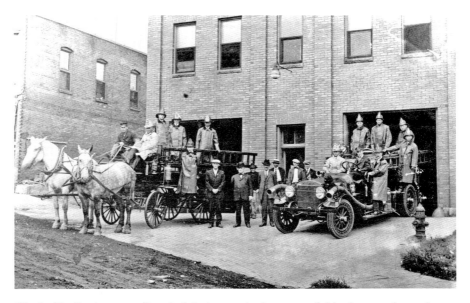

Charles Verdier, known as Snowball, is the man in the center of this photograph wearing a straw hat. The scene is the South St. Paul Fire Department on Grand Avenue, where the firefighters are showing the contrast between the horse-drawn fire wagon and their new five-hundred-gallon Waterous pumper. Harry E. Rund was fire chief at the time. Augustus Francis was secretary and A.E. Henness president of Company 2. *Author's collection.*

nicknamed him "Snowball" and took him to the police station. He did odd jobs around city hall, kept the jail clean and basically lived there for thirty years. In 1953, when the old city hall was to be demolished, he became ill and was moved to the Crispus Attucks Home in St. Paul and subsequently to Riverview Memorial Hospital, where he died on May 17, 1953, at the age of seventy-three. The local police force took up a collection to prevent him from being buried in a potters' field, and six local officers served as pallbearers at his funeral on May 18, 1853. Charles Verdier was, according to Officer Jack Yeaman, "too good a man to end up in a potters' field. He was the only colored man who resided in South St. Paul and everybody just loved him." Charles Verdier is buried at Oak Hill Cemetery.

Today, South St. Paul is home to an ever-growing population of African Americans, Latinos and many other minority groups. Affordable housing prices, city services, excellent schools and access to public transportation make our community an excellent first home choice for young families. Just as the school district of the early 1900s welcomed non-English-speaking students into their classrooms and provided assistance and guidance to families from around the world, today's educators, school administrators, community education leaders and employers support and encourage the incorporation of these new residents to South St. Paul.

5
South St. Paul Women

Why would this history of South St. Paul include a chapter on South St. Paul women? It's because in many ways, the economic and social heritage of the city created a uniquely progressive community of women that didn't exist in other Twin Cities suburbs.

For one thing, the meatpacking industry offered employment opportunities to women, unlike the northern Minnesota mining operations, which also attracted European immigrants in large numbers. Women who braved the journey to South St. Paul, even single women, could work in the plants in a variety of jobs. For married women, the possibility of paid employment was often a completely new option, and if she and her spouse both worked, they could soon save enough money to move out of their Concord Street boardinghouse and buy or build a new home in their adopted city of South St. Paul. For single women, the opportunity to work in the plants offered them an independence that they could not find anywhere else unless they had gone to a teachers' college or had some kind of post–high school degree. Of course, women were never paid as much as men, even during the labor shortages of the Second World War, but Swift's and Armour's offered opportunities that women couldn't find anywhere else.

In addition to employment possibilities in the livestock industry and related businesses like banking and insurance, hundreds of South St. Paul women owned and operated small businesses like grocery stores, cafés, boardinghouses, retail shops and ice cream parlors. It was not at

South St. Paul

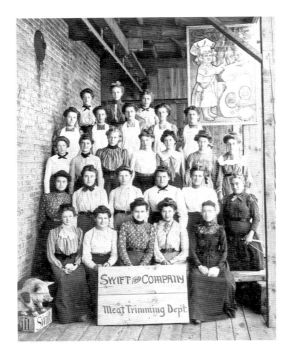

Left: South St. Paul offered women of all ages the opportunity to work and created generations of strong-willed, hard-working, independent-thinking women who were among the first to ever vote legally in the United States on August 27, 1920. These women are from the Swift's Meat Trimming Department in about 1910. *Dakota County Historical Society.*

Below: Women poured into jobs in the packing plants when men were drafted into service during World War II. *Dakota County Historical Society.*

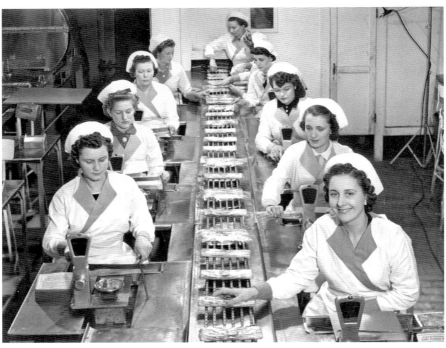

A Brief History

Women made up over 30 percent of the workforce at Armour's when the plant closed in 1979. These two workers from the Offal Department used their lunch break to catch up on their knitting. *Manuel Aguirre, photographer.*

all unusual for a couple to invest in a family-owned operation either in the heart of the Concord Street business district or on a corner in a residential neighborhood where homemaker moms would send the kids to the corner store for milk, bread, eggs and other groceries.

South St. Paul was also home to women who were descended from the elite American families of the East Coast. These old-time Americans whose ancestors had been in the country since the 1700s were the wives of the bankers, commission men and investors who came to South St. Paul because of the burgeoning livestock industry. Although they weren't pioneers in the same sense as the women who crossed the prairies in the 1850s, these society women were coming to a rough-and-tumble stockyards town where cowboys and cattle ruled. Their husbands were the foundation of the new industry, accepting lucrative positions with elegant offices in the Exchange Building. They built stylish new homes in the center of the city or in Charles Clark's charming neighborhood of South Park.

The women immediately began to enhance South St. Paul's local culture by establishing women's clubs and organizations reflecting similar groups in which they participated out east. Women were also the driving force behind the language, music, clothing, dance and cooking traditions that were preserved and promoted by the ethnic halls. The Serbian Mothers carried on a proud tradition for generations and the Croatian Tamburitza Orchestra included female musicians. Dancers from all of the halls performed throughout the Twin Cities.

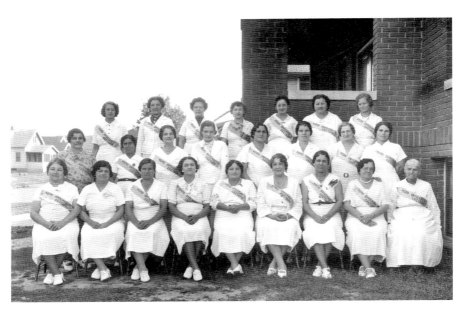

Women from the various ethnic societies have kept the customs, foods and traditions of their native countries alive for generations. This group of the Serbian Mothers organization was photographed outside the Serbian Home about 1950. *Dakota County Historical Society.*

It was the South St. Paul school district that brought all of these women together, first at their neighborhood elementary schools and then through junior and senior high school. As their children learned together, played sports together and finally graduated together, the women came to know one another through Mothers' Clubs and PTAs. It would be naïve to say there was no class distinction or occasional tension, but it is also safe to say that South St. Paul was a successful melting pot where rich and poor, American born and foreign born, came together at every turn.

South St. Paul Women First to Vote

Several women from South St. Paul were active in the suffrage movement in Minnesota. Women around the country had been seeking the right to vote ever since the United States was founded. Efforts heated up when African American men were enfranchised in August 1869, but white and African American women were not. Resistance to allowing women to vote was often

because the suffrage movement aligned itself with the Women's Christian Temperance Union. Men in power feared that if women got the vote, they would somehow impose prohibition of alcohol across the nation.

By the time America entered World War I in 1917, women had made significant strides toward equal voting rights, but the war halted efforts as women took on additional responsibilities both at home and on the front, where they served as nurses and administrative workers. The suffrage movement politically promoted the fact that women served the nation during the war but were still not treated as equals in the voting booth. It is ironic that even without the women's votes, prohibition of alcohol was imposed on the nation on January 17, 1920.

The Nineteenth Amendment to the U.S. Constitution allowing women to vote was passed by Congress on June 4, 1919. Ratification by the states followed, with Minnesota adopting the amendment on September 8, 1919, the fifteenth state to do so. By March 1920, only thirty-five states had ratified the amendment with thirty-six needed before the August deadline. The thirty-sixth state to ratify the amendment, allowing it to take affect, was Tennessee, which met the deadline with its vote on August 18, 1920. Congress accepted ratification and enacted the Nineteenth Amendment on August 26, 1920.

South St. Paul had scheduled a special water bond vote for the morning of August 27, 1920. Notice of the election had been posted on August 6, too early for them to have predicted that women would have the vote by August 27. As it happened, however, South St. Paul women were ready and waiting, and eighty-seven local women became the first to vote legally in the nation when they entered their polling places at six o'clock that morning. The *St. Paul Dispatch* for Friday, August 27, ran a banner headline that read: "SOUTH ST. PAUL WOMEN FIRST TO VOTE UNDER AMENDMENT: Group of New Citizens Waiting When Polls Opened at Suburb, 6 a.m."

Among those who voted that morning were Macha Grannis, a civic leader and community activist whose husband, David L. Grannis, was a local attorney. Katherine Michelmore, the society editor of the *South St. Paul Daily Reporter* and wife of Thomas T. Michelmore, one of the founders of the Livestock Exchange, voted that morning, as did her daughter Katie. Ida Kuckler, the wife of Ward 2 city councilman Conrad Kuckler, joined them, along with Mrs. John E. Fearing, who cast the first female vote in Ward 1. Marguerite Newburgh, the daughter of Councilman Louis H. Newburgh, and Mrs. Theresa Tiedman Kramer, wife of Councilman George Kramer, were also among the women casting ballots that morning.

Despite the prominence of these society women, however, the majority of female voters that day were representative of South St. Paul women: women who worked in the packing plants, in the offices, in the grocery stores and in the retail shops. Women from every ethnic background and every economic status stood in line on that historic morning to be among the first women in the United States to finally cast a legal vote. All the votes were counted separately from the men's just in case a legal technicality somehow voided the results, but no challenges arose. The $85,000 water bond passed that day, but the big news, of course, was the women's successful battle to become fully enfranchised citizens of the United States.

Women in Elected Office

It was twenty-five years after the historic 1920 elections before a South St. Paul woman held public office. Dorothy Rund Jerhoff was elected city treasurer in 1945 and was followed by Gertrude Wilson, who held that post for six years. In 1953, Zoe Giguere Francis was elected treasurer and remained in office for seventeen years. Helen Healy was the first woman on the city council, serving from 1953 to 1955. It was then another twenty years before Karen Frownfelter was elected to the council in 1975. During that same term, Virginia Lanegran was appointed to the council and was reelected to several terms through 1987. Kathleen Gaylord was first elected to the council in 1985 and served two terms before becoming mayor in 1993. Katherine Trummer was elected to the council in 1987 and became mayor in 1989. I was elected in 1989 and served until 1993. Jodelle Ista was elected in 1991 and served until 1999. Cindy Veith joined the council for one term in 1999. Lori Hansen and Jane Rund were elected to council in 2001. Rund served one four-year term, and Hansen has been reelected every four years since. Beth Baumann was elected as mayor in 2003, a position she still holds in 2015. Micky Gutzmann and Marilyn Rothecker joined the council in 2007. Micky served one term, and Marilyn Rothecker continues to serve in 2015.

In 1989, Katherine Trummer became South St. Paul's first female mayor. She was a relative newcomer to the council, having been elected in 1987, and she ran against incumbent mayor Bruce Baumann two years later. Kathleen Gaylord, who had been on the council for ten years, ran against Trummer for mayor in 1993 and became the city's second female mayor.

A Brief History

South St. Paul has elected a woman as mayor every year since 1989. Katherine Trummer (top left), Kathleen Gaylord (top right) and current mayor Beth Baumann (right). *City of South St. Paul.*

Kathleen went on to be elected Dakota County commissioner in 2002, and South St. Paul's third consecutive female mayor, Beth Baumann, took over the position her father, Bruce Baumann, had held from 1985 to 1989. Beth Baumann is the mayor of South St. Paul in 2015.

6
Neighborhood Memories

Ever since the Dakota were removed from Kaposia to reservations in western Minnesota, South St. Paul settlers began staking claims for land and platting out the borders of their new farm fields and home sites. It soon became clear that the area presented challenges. From the northern border at what is now Annapolis, to the southernmost property at South Street, South St. Paul is slashed by several dramatic ravines that were formed by the glaciers thousands of years ago. Starting at the north end, the massive Simon's Ravine effectively cut off the far north end of town from the area that came to be known as South Park. Then, just south of Bryant, the Central Avenue ravine provided yet another huge divide. Proceeding south, the next major chasm was at what is now Wentworth Avenue. The far south end of town was ultimately cut off from the rest of the city by what became known as the Church Street ravine, today's I-494 corridor.

These natural geographic divides led government officials, school directors and settlers to choose which side of which ravine they would build on, creating neighborhoods that continue to define the character and nature of the community to the present day. Many current residents recall the days when which neighborhood school you attended in many ways determined your social status when all students were brought together in junior high. The kids from Wilson School in the North End had probably never met someone from Washington in the South End before encountering one another in seventh grade. Lincoln School kids had a tendency to look down on the students from Central and Roosevelt, and it is a well-known fact that

South St. Paul

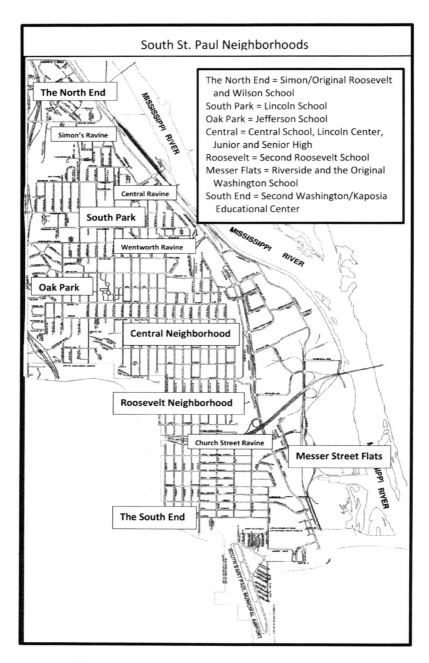

South St. Paul Neighborhoods. South St. Paul's four major ravines and the various neighborhoods that grew up around the area's elementary schools are identified on this map.

A Brief History

Jefferson School students felt they were the cream of any crop. In similar fashion, ask nearly anyone who grew up in the South End what it was like to be from Washington School, and you get a sense of what it felt like to be considered the bottom of the barrel. Yet another influx of newcomers joined the mix when the students from the parochial schools—Holy Trinity, St. Augustine's and St. John Vianney—entered in ninth grade.

Like the city schools, churches were also an important part of defining neighborhoods. The ethnic congregations of St. Sava, St. Stefan and Holy Trinity were part of the heart and soul of the Roosevelt neighborhood, just as Clark Memorial was the center of South Park's religious community. The seven churches in the center of town were constant reminders of the Christian principles that nearly everyone embraced. Several people have mentioned to me how no one would ever be caught mowing the grass or gardening or even just sitting on the porch on Sunday mornings. The expectation was that everyone would be in church and then observe the remainder of the Sabbath by not working. Nearly every business was closed on Sundays, and there was no such thing as a 24/7 big-box retailer in sight.

In 2015, Clark Memorial UCC, Holy Trinity, St. Sava, St. Stefan, St. John Vianney, First Presbyterian, Luther Memorial (formerly St. Paulus

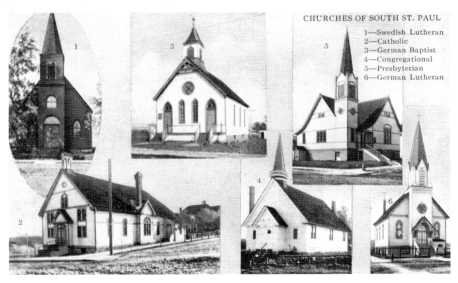

This 1917 postcard was produced by the South St. Paul Commercial Club as part of a souvenir booklet designed to promote the city to potential investors. The churches at the time were (top, left to right) Bethesda Lutheran, First German Baptist and First Presbyterian and (bottom, left to right) St. Augustine's, Clark Memorial and St. Paulus German Lutheran. *Author's collection.*

German Lutheran and Trinity Norwegian Lutheran), Grace Lutheran and Concordia Lutheran are still located in South St. Paul. First Calvary Baptist, South St. Paul Assembly of God and Bethesda Lutheran have moved to Inver Grove Heights, and St. Andrew's Episcopal (now St. Anne's) has relocated to Sunfish Lake. First United Methodist Church closed in 2011. In 2015, the former Bethesda Lutheran Church is home to the Celestial Church of Christ. The South St. Paul Hispanic Seventh Day Adventists are now owners of the former First United Methodist Church and the former First Calvary Baptist is home to St. Mary's Coptic Orthodox Church. Asamblea Apostolica de la Fe en Cristo Jesús now owns the former St. Andrew's Episcopal Church.

The River Flats, Riverside and the First Washington School

The first public school for the area was established in 1857. Miss Margaret A. Brown taught about twelve children in a one-room shanty on the property that would be near Sixth Street South and Concord Street today. In 1865, Dakota County bought one-quarter acre of property from Silas Bolles and established a school on the land where the I-494 and Concord ramps are today. The new City of South St. Paul took over that school in 1887 and named it Riverside. Today, that spot seems particularly unusual for a school site. It has been business or industrial property for decades. Many residents have no idea that this area east of South Concord Street was a booming neighborhood for nearly one hundred years with platted lots, streets and comfortable family homes dotting the landscape leading to the river. The area was attractive for several reasons. It was flat and accessible by the only major thoroughfare through the area, the St. Paul and Hastings Road, as Concord Street was originally called. Travelers could avoid the steep climb up to the top of the bluffs and travel north or south without a problem, at least when the spring floods didn't make Concord Street impassable. It was also close to the rapidly growing meatpacking industry, which was where most new immigrants found their first jobs.

Joe and Katie Pechanec purchased the old Riverside School building in the spring of 1890 for seventy-five dollars and moved the building to the northeast corner of Concord and Church Streets so the city could build a new Riverside School, designed by architect John H. Coxhead and opened in December 1891. Overcrowding led to the decision to build a new school

on the site in 1906. By 1907, the new Riverside School housed more than 160 students, and the following year a four-room addition was built to accommodate the growth of the number of residents in the neighborhood. That same year, the school was renamed Washington in honor of the nation's first president.

The children who attended the new Washington School lived on the "flats," as the Messer Avenue neighborhood was known. Their families shopped at the constantly expanding business district along Concord Street and had no reason to venture up the steep bluffs where the first shops were starting to be built "on the hill."

The neighborhood gradually disappeared, however, as annual flooding prompted the city to start buying up property as it became available and eliminating any residential properties in the area. Washington School was demolished in 1928 and no new school was erected on the site. In the 1930 *Polk City Directory*, the Maltby, Malden and Messer Streets neighborhood was still home to twenty-six families, even though South Concord Street was rapidly being transformed into industrial use. The residents had learned to live with the annual flooding of the Mississippi, but by 1961, all but one of the residents of the area had been bought out and removed from the floodplain; only five residences remained on Maltby and Malden Streets. Ten years later, four homes remained, and by 1982, Paul French, the last person to own a private home at 925 Messer Street, was gone.

Church Street

Church Street, today's I-494 corridor, was almost a neighborhood unto itself. Residents who lived in the bottom of the steep-walled ravine were isolated from both the farmland to the south and the city center to the north. Named after the little German Baptist Chapel at Church and Concord Streets, the street was home to George Nechville's Grocery at 1000 Fifth Avenue South. Sharon Nechville Olson wrote:

> *Growing up in South St. Paul in the '40s and '50s, life was almost like a story. I lived on Church Street (Highway 100), where trucks were constantly taking livestock to the packing plants. Along with Concord Street, it was likely one of the busiest streets in town. My father, George, owned Nechville's Grocery on the corner of Fifth and Church, and I thought I was*

the luckiest kid in the area because of that store. I got to know all of our neighbors (women shopped for each meal back then) and eventually was able to work there during the summer.

From the windows of our apartment above the store, I could watch men walking home from the plants or other Concord Street businesses. Even our resident policeman, Arthur Giguere, would come down the hill in his uniform. I always felt safer because he lived two houses away from us and, in my eyes, could protect us from anything.

Across the street from the store was a gas station called Al's DX. The station was staffed with a couple of mechanics who could fix just about any car. In back of the station were pieces of cars and trucks. I have no idea what they were for, but it was a great hiding place in the evening when we played hide and seek.

In the winter, my mother would flood the lowest part of the yard and make a very irregular and bumpy skating rink for us. She taught my sister and me to skate by pushing an old chair in front of us. In the summer, the trees formed a perfect softball diamond, and we and some of the neighborhood kids would play a not so terrific but fun game.

Along the alley between Fifth and Sixth Avenues was our garage and an attached building of equal size that had been my grandfather's chicken coop. It had a little side yard that was perfect for making mud pies. Again, my mother stepped in to make something wonderful for us. She hired a neighborhood boy, Peewee Huntington, to clean out the building, and then she gave us cardboard, nails and a hammer. We lined the whole interior with those pieces of cardboard and then painted them. Pink as I recall. About three-fourths of the building had a wood floor, so we furnished it with whatever furniture we could find. And Mom made curtains for the two windows. We spent so many hours in that playhouse and did such dopey kid stuff. Like trying to make perfume from a lot of flowers we found in a neighbors trash can. (And the perfume smelled more like trash than flowers.) As we got older, Mom helped Susan turn the playhouse into a school to which the little kids in the neighborhood came every morning. Looking back, it was kind of a daycare that gave the moms a couple of free hours. Susan became a teacher, so I guess the experience was a good one.

Summers were awesome, but winters weren't bad either. We were bundled up in snow suits—heavy wool pants and a matching heavy wool hoodie jacket, rubber boots that fit over your shoes and zipped up the front, woolen mittens and a wool scarf tied around your face so only your nose and eyes were visible. Remembering it now, I'm amazed that we could move, let

alone play or walk to Washington School. We did all of those things and more and had a wonderful cold, wet time.

I wouldn't trade my childhood for anyone else's. We had so many great adventures, and our snow suits, swimming suits, roller skates and ice skates are keys to so many of my memories. I miss it a lot.

Church Street gave way to the interstate starting in 1959, and today, there is no remaining evidence anywhere that hundreds of schoolchildren once headed home to Church, Messer, Maltby or Malden, to their neighborhood homes next to their neighborhood school.

South Park, Two Lincoln Schools and St. John Vianney Catholic School

One of the most charming neighborhoods in South St. Paul was named South Park by its founder Charles Clark. South Park extends north from Wentworth to Simon's Ravine on the bluffs above Concord Street and east to the river. It encompasses the Central Avenue ravine and was the site of Clark's famous electric monorail in 1888. South Park houses range from charming small bungalows to big Victorians like Arthur Clark's home at 1023 Highland Avenue. The Clark house was the heart of South Park in the early 1900s. It had the first windmill-driven water well and provided water for South Park families, and the Clark girls played tennis on the family tennis court. Many homes in the neighborhood were constructed with the uniquely shaped and shaded blocks from Dave Lindblom's cement block yard next the Clark house. The neighborhood shopping area was centered on Bryant and Concord at the Clark & Company Grocery store and the elegantly appointed Ten-O-Nine Hall where public programs and private parties were held in the third floor ballroom.

South Park had its own Federal Post Office until 1925, and was home to one of the city's earliest schools, the original Lincoln, built on the northeast corner of Fifteenth Avenue North and Bryant in 1887, on land donated by the Clark-Bryant Company.

By 1907, Lincoln School was overcrowded and the need for more space became urgent. Construction began on the second Lincoln Elementary School on the north side of Thompson Avenue between Twelfth and Fifteenth Avenues North in 1907, and the first classes met at the new school

Arthur D.S. Clark, Charles Clark's cousin, opened the Clark & Company Grocery Store in the Bryant Block on Bryant Avenue and Concord Street in 1887 and built his growing family this historic home at 1023 Highland Avenue. *Dakota County Historical Society.*

Dave Lindblom operated a block yard in South Park behind 721 and 733 Tenth Avenue North. The windmill at the Clark house is visible in the background. Lindblom's distinctive cement blocks were used in construction of many of South Park's gracious homes. *Reinhold O. Werner photograph collection.*

A Brief History

in 1908. The Bly family bought the old school building on Bryant, tore it down, and built their family home, which is still on the corner of Fifteenth and Bryant in 2015.

One of the other major attractions of the South Park neighborhood is the Northview swimming pool, which opened in 1956 between Thompson and Congress Streets and Eighteenth and Nineteenth Avenues North. Today's Northview Park also includes ball fields, and the pool is still a major draw for families from all over the city in 2015.

Sue Oestreich Grove shared her memories of growing up with her parents, Marvin and Lorraine Oestreich, at 1041 Sixteenth Avenue North.

> *I had no idea when we moved to South St. Paul in May 1955, that I was a part of the national phenomenon of suburban growth and a member of the baby boom generation. All I knew was that we had a brand-new house in a growing neighborhood in the north end of South St. Paul.*
>
> *Memories of Lincoln were those of reading groups with clever names designed to hide the fact that they were ability grouped, spelling, practicing cursive writing, social studies and arithmetic. Highlights included going to the school library, Christmas programs and playing kickball and softball outside. I also loved being a Blue Bird and Camp Fire Girl. I walked the eight-tenths of a mile to school in the morning, back and forth for lunch and home again after school. Very few kids took the bus—even to the high school. Girls had to wear dresses, but when it was cold, we wore wool slacks under them. We took them off at school and hung them in the cloak room, which then smelled like wet wool from the slacks and mittens.*
>
> *The years blend together, but I clearly remember everyone being taken to the community room in the basement for polio shots after the vaccine had been approved. We were all relieved because we had been scared of contracting the dread disease. This amazing initiative had been organized mainly by our mothers.*
>
> *A terrifying experience for everyone was taking part in air raid drills. We periodically had to grab our coats, crawl under our desks and cover our heads while the sirens blared. We were told that this would protect us from a nuclear blast! The school was an air raid shelter, so the yellow and black signs went up and barrels of food and water appeared—all lending to a creepy atmosphere for kids.*
>
> *In 1958—fourth grade for me—we celebrated Minnesota's centennial. I dressed up in my great-great-grandmother's bonnet and dress for a play*

about Minnesota pioneers. It was quite exciting. We each had to sing a solo of the Minnesota state song in front of our class. Talk about terrifying!

In sixth grade, I was chosen to be a crossing guard, which was a big deal for me. I loved when it rained and we got to wear the canvas rain ponchos!

Summer days were mostly carefree. Neighborhood kids gathered to go exploring in such exciting places as the ravine that led to Kaposia Park or Concord Street. Of course, our parents had told us not to go there because there were "bums" [who] roamed the ravine. We made creations out of the wonderful red clay we found on the bluff above Nineteenth Avenue. We played a lot of sports and went to the North End pool two or three times a day. The girls had many sleepovers on the neighbor's porch.

I rode my bike to the public library and spent hours reading. We walked or rode our bikes everywhere, and no one worried. We went to Lincoln to do crafts and play games. I remember making bracelets out of long strips of plastic.

During Christmas vacation, we went to the ice rink on the tennis court between Fifteenth Avenue North and Summit Avenue. We skated all day with only a lunch break—without a warming house. We took our sleds and raced down the hill we called "Sunrise" before they put a road through and built houses.

Going to Lincoln School and living in an area that wasn't yet developed provided many unique opportunities. We had open areas of prairie-type growth and ravines, a sand pit and a place with red clay that gave us the chance to explore and "create" in nature. Because of the baby boom, there were always a lot of kids to play with in our neighborhood.

The teachers that I had were all women and all rather "old school," which worked well for me. They helped me develop study skills that have served me well all the way through grad school. Miss Frank, my fifth grade teacher, really instilled the love of learning in me. I had always loved to read, but she made me want to dig deeper. Looking back, I realize that their method of teaching did not work as well for students who had undiagnosed learning difficulties and who were most definitely ADD or ADHD. They suffered under the rigidity of the times.

We had a great deal of independence to roam outside and to create our own fun. We had television but watched it only with the family in the evening. Looking back, the '50s really was a good time to be a kid in South St. Paul.

The second Lincoln School served the community until 1986, when the building was sold to Dakota County, which operated a branch of the Intermediate School District No. 917 in the facility. The building was

demolished in February 2009 and replaced with a new Dakota County Community Development Agency Senior Program residential facility called Thompson Heights.

On the far western edge of old South Park at Nineteenth Avenue North and Bromley, a new Catholic parish was established as St. John Vianney Church in 1946. The new church was completed by Easter Sunday, April 6, 1947, and in 1950, Leonard Reising constructed a black tiled floor as a roller rink on the lower level of the church. He and his wife, Ruth, managed the rink. Children could skate for twenty-five cents; adults were fifty cents. Only a few years later, in 1955, a new church building and parochial school building were dedicated. St. John Vianney School served generations of families until 2012, when the local school was closed and operations merged with three other parish schools as the Community of Saints Regional Catholic School, located at St. Michael's Parish in West St. Paul. Today, St. John Vianney Church continues in worship and the school facilities are leased to Pathways to Play, a licensed and accredited early childhood program that serves children year-round from age six weeks through ten years.

Stickney School, Central School, South St. Paul Senior and Junior High Schools

One of the first areas of the city to attract new residents was the center of town, which basically started atop the bluffs above Concord at First Avenue South and extended to Fifteenth Avenue between Wentworth on the north and Fifth Street on the south. It included South St. Paul City Hall and the downtown retail areas that were beginning to open along Marie Avenue and Southview Boulevard. It was often distinguished from Concord Street by being identified as "on the hill." The first legal business was allowed on the hill in 1905, when Henry Glewwe opened Glewwe's Grocery store at its first location, 142 Fourth Avenue North. He moved the business two more times, first to 141 Fifth Avenue South and then to the southwest corner of Fifth and Marie Avenues, where Glewwe's remained in business until 1986. The families who built the graceful homes that line the streets in the center of town represented a diverse group of investors, business owners, educators and others, many of whom worked in the livestock industry but others who came to town for new opportunities.

The first school to serve this part of town was named after stockyards founder Alpheus Stickney, who donated land for the school on what used to be known as the west wing of South St. Paul High School.

The school was built in 1887 and a two-room addition was approved in August 1890, with a second story added by December of that year. Then in 1903, a janitor discovered a crack that went the entire length of the outside wall of the school. Wooden posts were erected as props against the walls in an attempt to make the building safe, but in 1904, a St. Paul building inspector declared the school condemned. There was no other place available for students, however, and classes continued. On some days, school was actually dismissed because of high winds, and teachers felt the pupils' lives were in danger. In April 1905, classes were terminated because the building was in such a dangerous condition.

A bond issue election passed in March 1905 allowed construction to begin on the new Central School on the block surrounded by Sixth and Seventh Avenues North between Marie Avenue and Second Street North. The new Central High School was an exciting project for everyone in town. The mammoth excavation itself was an adventure as mule teams hauled the excavation equipment, a fascinating operation for the little neighborhood boys who gathered to watch the progress at the construction site.

Stickney School was torn down as soon as Central was ready for occupancy and the land retained for future school use. By 1910, overcrowding at the new Central School was beginning to cause difficulties, and in 1911, the cornerstone was laid on the former Stickney site for a new Junior High School. As the number of elementary students also continued to increase, it soon became clear that Central was needed for that age group.

By 1921, high school student classes had completely taken over the new junior high and a $350,000 bond issue passed that year to build another new junior high as an addition to the 1911 building. The campus continued to expand, and in 1929, a twelve-room recitation hall was added with the auditorium construction beginning the following spring. The athletic field, formed by the natural Wentworth ravine, was created in 1930 and renovated in 1939, making the high school complex the envy of many others in the state. The high school campus has continued to grow over the years. In 2015, the former gym was demolished to make way for a new classroom space to accommodate sixth graders who will be attending the school in the fall of 2015 in order to create more space for prekindergarten classrooms at Kaposia and Lincoln Center Elementary Schools.

A Brief History

As the junior and senior high school facilities expanded, the former Central High School was renovated by having the third floor auditorium removed, replaced with a flat roof and extended classroom space on the first and second floors. Central served as the elementary school for students from this neighborhood until it was closed in 1975. Today, Central Square Community Center, the adjacent park and the amphitheater on Marie Avenue mark the site of the old Central School.

In 1951, as the city's population continued to grow, a new South St. Paul Junior High was built on the southwest corner of Ninth Avenue and Fourth Street North. The junior high was subsequently converted into an elementary school that is known as Lincoln Center in 2015, and junior high students moved to the high school campus.

The neighborhood at the center of town was a playground for hundreds of South St. Paul children who could wander the streets and pop into businesses on Marie Avenue and Southview for candy, ice cream or pastries or stop at one of the burger shops and soda fountains that became the hot spots for after-school gatherings of high school students.

Jim Servatius attended Central Grade School and shared some of his memories:

> *It was Christmas vacation during my fourth grade year when our family moved from South Concord Street to 151 Ninth Avenue North. Our house was two blocks from Central Grade School, one block from the Junior High and one block from the High School. Coming from Concord Street, it was a very pleasant change for our family. It was still a working-class neighborhood but with well-kept houses and properties. I noticed immediately how quiet it was compared to the hustle and bustle of Concord Street. Central School was an old building, but it was a pleasant environment, and I enjoyed going there.*
>
> *My first big discovery after moving to Ninth Avenue was hockey, as it seemed that just about everyone played hockey. The hockey rink and general skating rinks were directly across the street from my house so it didn't take me long to get involved with little league hockey. Baseball and softball were the spring sports and we mostly played at the Central School playground. I was also across the street from the high school football field, so naturally it was playing little league football in the fall. Track meets, baseball games, hockey and football provided nonstop entertainment and it was always within a stone's throw from my front yard. The activities were never ending. Besides the sports, we had sledding in the winter on the hills at the high school and cardboard sliding in the fall on cardboard from Mega Furniture.*

South St. Paul

We lived one block north of Marie Avenue so shopping was always within walking distance whether shopping for hardware at Bartl Ace Hardware, grocery shopping at Glewwe's or shopping for clothes at Gerkovich's, now B&G Crossing. There were service stations, barbershops, beauty shops, drugstores, bakeries and dry cleaners, all within a couple of blocks on Marie Avenue. If you couldn't find it on Marie, then you could go one more block to Southview Boulevard to find restaurants, TV repair and just about anything else one might need. It was a self-sustaining neighborhood, and it was also a close-knit neighborhood with literally everyone knowing everyone else. It was an era when people looked out for each other and looked after one another. If one was acting up, they were likely to be scolded by somebody. It may not have been your own parents doing the scolding, but they would be respected just the same. It was a time when kids respected their elders, no matter who they were.

The Central neighborhood was known for having lots of kids, and our block was no exception. Just between our family and our next-door neighbors, we would grow to have sixteen kids in two adjacent houses, and we were not atypical. What that meant to us kids was there would never be a time when you couldn't find somebody to play with, and play we did. Within one block of our house, there were still some nice wooded areas and some deep ravines as well, so a kid could get lost in his or her imagination quite easily. We built tree houses with scrap lumber and built forts out of the ubiquitous furniture boxes from Mega Furniture, also on Marie Avenue. We built forts in the summer and more forts in the winter, always from scrap wood and cardboard. In the winter, we would ventilate them and build a fire inside for boiling water to make hot chocolate. There absolutely was never a moment in our lives when we weren't outside unless we were in bed sleeping. While we were sleeping, we were dreaming about the next day's mischief—I mean activities. There were no days in our winters that we felt it was too cold to play outside. If it was cold, we put more clothes on but never gave consideration to staying in the house.

One of our hobbies was to explore, and explore we did. We explored every nook and cranny we could find, whether or not we had approval or permission. What is now the high school football practice field was a large ravine that went north from the Third Street bridge to the city pump house on the bottom of the Wentworth Avenue hill. There was an opening to a storm sewer that ran all the way to the Mississippi River, and it was big enough to walk upright in it. We would be equipped with flashlights to see where we were going and it was amazing how much neat stuff we found

in that amazingly scary sewer, including rats the size of small dogs. Of course, our parents never knew we were in the sewers, and we never offered up any evidence that we were.

It was the 1950s and, in this man's opinion, the greatest decade of my lifetime. It was a great time for a kid growing up whether in South St. Paul or anywhere else. Rock-and-roll had been invented, and the cars and motorcycles were the coolest of any era before or since. It was much more a time of innocence and a time when everybody didn't think they had to have everything. We were all pretty much working class and were happy just having the essentials of life. There were, of course, some pretentious people, but we didn't relate to all that and were quite happy with what we had.

There was just simply not one moment in that neighborhood when we couldn't find something to do. All it took was a vivid imagination. And whatever it was we were doing we always felt safe, and our parents felt we were safe as well.

I will say that it was kind of a tough neighborhood, and kids were very territorial in those days. If you were from Lincoln or Wilson or Roosevelt, you probably were better off staying in your own neighborhood. But then, we stayed in ours as well. In the fall, though, we would organize football games with kids from other schools and neighborhoods, and it was very serious stuff to have the bragging rights. I enjoyed being from the Central School neighborhood, and I would not have traded it for anything else.

St. Augustine's Catholic Church and School

St. Augustine's Catholic Church was officially established on June 11, 1896, and the first chapel on the corner of Grand Avenue and Third Street North was dedicated on August 30, 1896. Extensive renovations were made to the church by 1916 to accommodate the growing congregation. Then on March 31, 1923, the church was completely consumed by fire. There was time to save most of the vestments and treasures of the parish, but an inadequate water supply via the hydrants meant that the firemen battled the flames for several hours without success. By Christmas Day 1924, Mass was held in a new facility that the church had built on its current site at 408 Third Street North. St. Augustine's parochial school for grades one through eight opened on the new campus in the fall term of 1925, and continued to serve generations of local Catholic families until the school was closed in June 1977.

The Far North End, Bircher and Simon/Roosevelt/Wilson Schools

Simon's Ravine, more commonly known as the Kaposia Park or Nineteenth Avenue North ravine, effectively cut off South Park from the rough, rocky bluffs that characterized the far north end of the city between Butler and Annapolis Avenues. The early settlers in this part of town were mostly berry and fruit farmers, and during the spring flood season, when the Mississippi River took over Concord Street, they were isolated, unable to travel to the center of town until the waters receded. Still, by 1888, the new city of South St. Paul realized that it needed to provide a school for the children of the North End. William Bircher, a farmer who had come to town after serving as a drummer boy in the Civil War, offered to rent a room to the city for a school in one of his outbuildings on Bircher and Willis Avenues for twelve dollars a month. Classes began at Bircher School in January 1888.

Within two years, the one-room Bircher School was no longer able to accommodate the new families who had moved into the North End, and a new school, designed by John H. Coxhead, who also designed South St. Paul's first city hall, was hired to build a new school on what was then known as Simon Avenue, after John Simon of Simon's Ravine. Today, the site is directly west of where Outlook Avenue crosses Stickney. The Simon School opened for classes in January 1890. In 1903, the name of the school was changed to Roosevelt.

By the end of 1916, Roosevelt School was no longer large enough to accommodate the number of students and a new school was built on the north side of the old building. Named Woodrow Wilson Elementary, it was described in the *South St. Paul Daily Reporter* newspaper as the most modern in the city. It contained a gymnasium, cooking room, library, manual training room and dressing rooms with showers for both boys and girls. Students moved from the old Roosevelt into the new Wilson School on April 11, 1917.

Wilson School served the North End students until it was closed in 1971. It was later used for school district administrative offices. The building was demolished in 1983, and today, the site is Wilson Heights, one of the city's newest and most prestigious neighborhoods, with elaborate multistoried modern homes overlooking the Mississippi River.

One of the other major attractions of the North End is Kaposia Park, named after the original Mdewakanton Dakota village that was located at the eastern edge of the park along Concord Street. The early South St. Paul City Council showed tremendous foresight in setting aside the eighty-

A Brief History

five-acre space for public park use in 1888. No amenities were added for several years, but in 1937, a Works Progress Administration (WPA) project allowed construction of the log pavilion. Kaposia Park's terrain remains mostly natural with large mature trees and varying topography, including Simon's Ravine, which provides access to the paved Dakota County regional river trail. In addition to the pavilion, the park also features a picnic shelter, a small ball field, horseshoe pits, a sand volleyball court, a playground area, a paved and boarded hockey rink accessible from Bromley Avenue and tennis courts accessible from Conver Avenue. Kaposia Park is home to a premier twenty-four-hole disc golf course that was begun as a nine-hole course built by volunteers in 1988. It has been host to state, regional and international disc golf tournaments.

Andrea Twedt, whose grandparents John and Francisca Karnstedt Weir bought the William Bircher home in 1902, shared her mother's memories of growing up in the North End for the 1987 *South St. Paul Centennial History*. There were eight Weir children. Andrea's mother, Dorothy "Dode" Weir Twedt, was the youngest, born on October 7, 1909.

Civil War drummer boy William Bircher built his home in South St. Paul when he arrived in town as a young man. The Weir family purchased the property in 1902, and it still reigns above the river on Bircher Avenue. *Author's collection.*

Lil and Butch were enthralled by the number of places to explore after the family moved into the big house on Bircher. The home, with its two barns and a windmill, was located on two large outlots, each of which was the size of three or four city lots. When the children had become familiar with the house, yard and ravine, they went on to explore the river flats below. The flats became a favorite spot for them, and when they did not have to help with the chores or watch the younger children, they were quick to put their fishing poles on their shoulders and trudge down to the river, picking berries and hazelnuts on the way and pausing to examine an occasional bullfrog or garter snake.

Winter was a time of great fun, with steep slopes on which to ski, toboggan and bobsled. Dode even liked to take her skies with her to school, carrying them all the way up Bircher Avenue to Wilson School, just so that she could ski down the hill when classes were let out.

The spring slough was another site of neighborhood winter activity. It was nestled between the two sets of railroad tracks, just southeast of the end of Bircher Avenue. Although one end of the shallow slough stayed open all year because of the spring, the other end became an ice skating rink. Because there was no warming shack at the slough, the children would sometimes put on their skates up at the house and then totter down Bircher, across Concord, down the steep bank, and across the first set of railroad tracks only to find that their blades had become a bit dull en route. Both astounding feats and painful crash landings were performed at the site when enthusiastic skaters forgot about the bumps in the surface of the ice—the slough was no man-made arena. Many years later, my friends and I would take just as many spills on the bumps and protruding weeds of the old slough.

During the kittenball [a sport similar to softball popular at the time] *season, Willis Avenue became the locus of neighborhood activity. Outfielders took up their positions at the intersection of Willis and Bircher. The steep Bircher hill, which provided so much fun in winter, was quite another matter in the kittenball season. Many a fast-moving ball went past a slow-moving fielder and on down Bircher, the unfortunate fielder running pell-mell behind it in an all-out effort to retrieve the object before it reached Concord Street, or even worse, the river flats beyond.*

John Weir worked in the packing plants for many years but then became a grocer with his little store at the foot of Bircher Avenue on Concord Street. The building is still there in 2015. He made the trip to the St. Paul Farmers' Market every morning to pick up new produce and although the

store didn't do much business, it was a great place for John to enjoy chatting with neighbors. Many Wilson School kids recall running down the Bircher Hill after school to buy enough penny candy there to see them through the long trek back up the steep hill to their north end homes.

A New Roosevelt School in a New Neighborhood

By the end of World War I on November 11, 1919, South St. Paul's population had grown to over 6,800 people, a 52 percent increase since 1910. The new Armour's meatpacking facility opened in December 1919, and hundreds of immigrants from war-torn Europe were pouring into town to find jobs. Residential housing boomed to the south of the center of downtown as many of the families wanted to be close to the Polish, Serbian and Croatian social halls and ethnic churches in the neighborhood where they would find their friends and relatives. In March 1921, a $350,000 bond issue made it possible to build a new elementary school on Fifth Avenue South to accommodate the children of these new arrivals. The land for the school was a horse racing track, according to early accounts. Ed Tiedman of South St. Paul entered a contest to name the new school and suggested Roosevelt, which was the winner, named in honor of Ed's hero, Teddy Roosevelt. The new school opened officially for classes on January 19, 1923.

The students at Roosevelt represented a true melting pot of cultures, religions and ethnic traditions. Several teachers from there have told me over the years that it was a wonderful school. The parents were truly dedicated to seeing that their children learned to speak English and got a good education even while they themselves were often attending night school citizenship classes. In 1929, when the old Washington School on Concord Street was closed, the children from Concord Street and the river flats also came to Roosevelt. John Sarafolean wrote on the Conversations of History in South St. Paul Facebook page on June 19, 2015: "As far as I know, many of the kids from Concord walked up the Sixth Street hill (without puffing). Urban legend had it that they were the toughest kids around. I never challenged that." Brian Winter added that there was a set of metal stairs that extended from Concord Street to about the 300 block of First Avenue South and John Sarafolean wrote: "We called them 'The Iron Steps' and they were adjacent to a partially hidden storm sewer tunnel that gave shelter to more than one

Roosevelt School opened in 1923 and remained as one of the city's neighborhood elementary schools until 1994, when it was demolished to make way for sports fields. This photograph will also remind residents of the days when nearly every kid went through bicycle safety training and rode a licensed bicycle. The summer program was offered by the city's Parks and Recreation and South St. Paul Police Departments. *Dakota County Historical Society.*

homeless person. The city removed them and placed a grate over the tunnel entrance, much to the relief of neighborhood mothers."

The Roosevelt neighborhood was also home to many corner grocery stores over the years. Such stores flourished all over the city but were particularly popular in the close-knit neighborhood around the school. One of those stores, Wegener's Grocery, was purchased by Joseph Fleischacker in 1955. He opened Joe's Bakery on the northeast corner of Fifth Avenue and Fifth Street South and then sold to Joe Woods in the early 1960s. The name remained as Joe's and was the last bakery in town before it closed in 2006. In 2009, American Family Insurance moved in and continues in business in the former bakery in 2015.

Another influx of students enrolled at Roosevelt in the years immediately following World War II. In 1945, Mike Kassan and other local developers began buying up the farmland to the south of Roosevelt and rapidly constructed the hundreds of bungalows that line Fifth, Sixth and Seventh Avenues from Fifth Street South to the Church Street ravine. It is said that a ditch would be dug down one side of the street and all the basements laid

and then one by one the houses would be completed for the men returning from the military who were anxious to settle down and establish their own families in South St. Paul.

One of the major amenities of living in the Roosevelt neighborhood was Lorraine Park, which is located between Fifth and First Avenues South and Seventh and Eighth Streets South. The McLain swimming pool, named after South St. Paul teacher Chick McLain, opened in 1939 and provided swimming fun to the neighborhood for sixty years. A new splash pool opened in 1993, and the main pool closed in 1999. The park remains a popular location for family picnics, outdoor worship services and sporting and civic events.

Roosevelt served the children of the neighborhood for over seventy years before it was closed and demolished in 1994 to make way for soccer fields.

The South End, Washington School and Kaposia Education Center

By 1929, South St. Paul's elementary schools were bursting at the seams and both Lincoln and Roosevelt were slated for additions. The city's population had risen by another 45 percent and was over ten thousand by 1930. The school board approved construction of a new school in the south end of the city to serve those students, but the site it chose, at First Avenue and Dale Street South, was loudly protested by parents. They felt it was so far out in the country that the roads would never be plowed that far in winter. A bond issue proposed to cover the cost of streets and sewers to the site was defeated, and a shortage in building funds required the architect, Toltz, King and Day, to make several changes in the plans. Then contractor Anton Mleczko died before the building was completed, leaving the construction in a confused state.

Plans prevailed, however, and the new Washington School opened for classes on September 13, 1929. Hundreds gathered in the new gymnasium to marvel at the modern facility, including the kitchen, large classrooms and even temperature of the building, thanks to the modern ventilating system. Mayor Thomas Prince promised the crowd that the roads to the school would be open in the winter and that he was sure they would find a way to pay for a sewer system very soon.

Despite the mayor's promises, the South End, as it came to be known, was geographically cut off from the rest of the city by the Church Street ravine.

The only sources of transportation were the streetcars on Concord Street or the bus that went as far as Church Street on Fifth Avenue South. It wasn't until the late 1930s, when Anton and Florence Rechtzigel founded the South and West Transit Company, that little jitney buses would make the trip to the very south end of town.

The South End Community Club was formed in the 1930s, and in 1939, the neighborhood was able to elect its first representative to city council when Clarence Anderson was seated. Several small grocery stores sprang up among the new little houses that were rapidly being built on the former farmland around Washington School, including Ed's at 101 East Richmond, owned by Ed Osterloh. The little store was known as John and Jane's until 1962, and in June 1967, it became Frez-R-Pak, home of the original No-Name Steaks, owned by Michael Trudeau and Steve Badalich. Currently No-Name Meats is owned and distributed nationally by the J&B Group out of St. Michael, Minnesota. Frez-R-Pak in South St. Paul was one of J&B Group's best beef customers, and it was impressed when it found people lined up outside to buy steaks in 1970. Today, Illetschko's Meats and Smokehouse continues to provide special cuts of locally grown beef, pork and chicken, as well as brats and other smoked meat products at this same location.

Washington School and the neighborhood grew up together in many ways. The South End is known for the tiny bungalows on forty-foot lots that often housed families with several children. Many people recall being teased about coming from Washington and the South End when they entered junior high in the center of the city. One comment that was shared with me was the taunt, "You guys live so far south, you have race riots," a particularly difficult statement to listen to in these more racially conscious days. Despite the taunts, today many of the tiny South End homes are handed down from parents to children to grandchildren as South Enders remain notoriously loyal to their unique neighborhood.

The Washington School on First and Dale served South End families for sixty-four years. It was demolished and replaced with a completely new facility known as Kaposia Education Center in 1993. In 2015, Kaposia and Lincoln Center are the last two public elementary schools in the city.

Kevin Holtorf grew up at 244 West Douglas in the South End in the 1960s. His parents were Kenneth and Delores Holtorf. He shared his memories of his childhood for this new history.

In short it was a wonderful, safe place to grow up! In a way, it was growing up on our own little island; we all knew the South End borders.

A Brief History

In my childhood, families were much larger than today's families, and most of the neighborhood kids seemed to know each other. Uniquely isolated from the rest of the city, we really had our own territory. To our west was Ninth Avenue, which had the Golden Oaks nursing home, and South St. Paul trailer sales. We stayed away, and respected Golden Oaks, but I loved to marvel as I peered through the fence checking out the newest trailers/campers every year. Going south down Ninth Avenue, every South End kid knew of Oak Bush! Really that was into Inver Grove, but it was our woods and wilderness. This is where we could check out nature in the city, on foot, on our bikes or even motorized mini bikes. This was before Upper Fifty-fifth and Highway 52 were built, a place where the neighborhood guys even camped out in some real adventurous times.

Our southern border was South Street, and it was huge news when McDonald's built in what once was just a cornfield. Wow, we could ride our bikes and go have a burger! Farther down South Street, where Fifth Avenue once ended, was Fifth Avenue Plaza with various stores over the years. The main stores were Town Drug, which featured a real old-fashioned soda fountain, also a hardware and grocery store. This was the original site of Pizza Factory, later to become Old World Pizza, still my favorite. The far end of South Street was the South St. Paul Airport (Fleming Field). Many a day did we ride our bikes to the airport to watch planes land and take off. At one time there was a B-17 bomber there that we could go right up to and check out, and imagine what it was like. For a while there were some pretty good airshows at Fleming, with plenty of aerobatics and even plane rides (Penny-a-Pound days).

The eastern border was the Mississippi River, for the kids old enough who were allowed to go down there with worms, or a can of corn to see how many Carp we could catch and release. On Concord Street, there were various businesses scattered, among them a favorite, Viking Pop, which featured a rainbow of mix-and-match pop for a reasonable price. Also down off Concord was the South St. Paul Rod and Gun Club. All kids were warned to stay clear; it was a safety thing we all understood. Farther down Concord was a furniture store that had a few different names and was "going out FOR business" for so long, but finally went OUT of business. Across the street, the infamous Golden Steer Motel, lounge and restaurant, almost a South St. Paul institution! This was a place for good food, entertainment and many a stockyard businessman stayed there for sure. For the neighborhood kids, it was a place to sneak down to, jump in the pool and run away before being caught. I don't remember anyone ever

getting caught, a lot of kids say they did it (jumped in), maybe some were even telling the truth about it.

That led back to our north border, 494, or Highway 110, as it was called back then. Everything within those borders was our little world. I can tell you the highlights. Penny candy at Millie's, a little store on Richmond Street where everyone went for a bag of candy, just point and pick; they filled the bag for you. The old stairs leading down to Concord from Chestnut Street, that and the woods around it was a great place to play ditch. This is right by Harmon Park and a place the South Enders called the Pines, because of the pine trees there by the tennis courts. The Pines itself was a good place to hide out back away from the street view, almost like our private clubhouse. We were lucky enough to have three ice skating rinks, one on Seventh and Spruce and two at Washington School, along with a warming house. There was McMorrow Field, at the time the South End's only baseball diamond and a great place to watch games on a warm summer night. I'm sure others have many more memories, but these are mine. It was during the baby boom, there were a ton of kids then. We felt safe to flood the streets trick or treating or going to the yearly Washington School carnival, to play neighborhood ditch or kick the can. Life was good for us back then; some say it was a much simpler time, just as previous generations have described their own childhoods. But we knew, too, we were a part, not apart, of this great hometown city of South St. Paul.

Oak Park, Jefferson School, the Miracle Center

One of South St. Paul's most ambitious and successful entrepreneurs, Mike Kassan, was among the first to take steps to bring the city an entirely new neighborhood in the post–World War II era. He called it Oak Park, and he laid out winding streets that meandered over the former farmland, earning the new area the name "Tangle Town." The development extended from Marie Avenue to Wentworth between Twenty-First Avenue North and the West St. Paul border. The first lots were ready to buy for $250 by 1947, and many families stomped through muddy fields following Mike around as he described the vision he had for this elegant and modern showplace. Lot No. 1 in the new Oak Park is today the southwest corner of Twenty-First

A Brief History

Oak Park brought South St. Paul its first truly modern neighborhood when western farmlands became the elegant area known as Tangletown. Mike Kassan was the developer of the property and advertised the "exclusive and restricted" development beginning in 1947. Mike's wife, Eva, and daughter Marilyn are pictured with the billboard. *Kassan family collection.*

and Wentworth Streets, and a variety of unusual lot shapes and sizes were platted outward from that point.

The end of the war had also led to the famous baby boom of the 1950s, and South St. Paul realized that it needed another elementary school to accommodate growing families. Jefferson Elementary School was built on Twenty-First Avenue at Southview Boulevard in 1954 and was doubled in size a year later. The school also reflected the modern architecture and style of the 1950s and included a broad expanse of land for a playground, a tennis court, ball fields and a wintertime skating rink and sliding hill. Jefferson became the real heart of the new Oak Park neighborhood as families from all over the city relocated to this elite new area as far away from the smells and sights of the stockyards as one could get.

In the heart of this new neighborhood, at 2023 Burma Lane, South St. Paul residents watched with excitement as contractor Herb Dillon began work on the city's very own "Blandings' Dream House" on land donated by Mike Kassan. The origin of the "Dream House" concept began when Eric Hodgins, an executive with *Fortune* magazine, decided that his growing family needed a home in the country rather than a crowded apartment in

South St. Paul

Twenty-first Avenue north of Southview Boulevard was nothing but a dirt road when construction began on Jefferson School in 1953. *Dakota County Historical Society.*

New York City. It was 1939 when he and his wife went looking for an old country home in Connecticut that they could remodel. Instead, they ended up building a new house that started out at a projected cost of $11,000 but which ended up with a price tag of over $56,000. The trials and travails of dealing with contractors, builders and decorators led Hodgins to write a book about the experience. His novel, *Mr. Blandings Builds His Dream House*, was published in 1946 and immediately became a bestseller. Within two years, 540,000 copies had been sold, and the movie rights brought $200,000 more. In 1948, Cary Grant and Myrna Loy were chosen to play Mr. and Mrs. Blandings in the RKO film of the same title. The film was immensely popular and received rave reviews around the country. More recent filmgoers might realize that a loose remake—*The Money Pit*, starring Tom Hanks and Shelley Long—debuted in 1986.

The director of the film, H.C. Potter, promoted the movie by sending a copy of the building plans to contractors, real estate developers, builders and architects all over the country. There was no charge for the plans, which came with detailed instructions concerning what color of paint to use in each room and how to select the best complementary towel color for the bathrooms. One of the movie lines about the house is Myrna Loy directing the painters, "Ask one of your workmen to get a pound of A&P's best butter

A Brief History

Blandings' Dream House brought fame to South St. Paul when it was built using the promotional plans for the Cary Grant and Myrna Loy movie of the same name. *Author's collection.*

and match it exactly…In the master bath, the color should suggest apple blossoms just before they fall."

On August 28, 1948, full-page ads ran in the metro papers inviting the public to visit Blandings' Dream House. Admission was twenty-five cents for adults with children under sixteen years of age free when accompanied by their parents. Proceeds benefited the Knights of Columbus Youth Program, the Rheumatic Heart Clinic of the St. Paul Chapter of National Jewish Women and the Cooperative Camp for Underprivileged Children. The ads featured photographs of the interior rooms, fully decorated. A billboard on Robert Street in West St. Paul advertised the turn to get to the house off Wentworth. Hundreds of area residents came to South St. Paul, many for the first time, and of course, Mike Kassan was there to offer to show them nearby lots where they, too, could build their own dream house.

The actual Dream House where the movie was filmed was not in Connecticut but in the hills above Malibu, California, at what was then known as Fox Ranch. It now serves as the administration building for Malibu Creek State Park. South St. Paul's Dream House is one of seventy-three that were built nationwide and one of the few that has remained in private ownership for residential use ever since.

Lots in Oak Park sold quickly, leading to Jefferson Elementary School's fast growth. Hundreds of families scrimped and saved in order to move to this prestigious new neighborhood. Some could only afford to finish their basement the first year and many lived in those basement houses until they could afford to add the above ground stories over time.

Despite its modern amenities, Jefferson Elementary School only remained open until 1983. The baby boom subsided and South St. Paul no longer needed the space. The building was sold to Word Church International in 1985. Pastor Tom Jestus led a Christian parochial school there for grades K-12 for several years. The congregation became known as the Miracle Centre of St. Paul and continued to worship in the space until closing in August 2014. The South St. Paul School District, which had retained ownership of the playground, sliding hill and skating rink, bought the building back in 2015, and discussions concerning future use of the site are underway.

I was a Jefferson kid myself and memories of entering a brand-new school remain fresh even today. I often tell people that going to Jefferson changed my life. The dividing line that determined whether I would go to Central Elementary or to Jefferson was the alley behind my parents' home on Fifteenth Avenue South. I was on the Jefferson School side and that meant that my childhood friends were almost all from Oak Park. They lived in modern new houses and had moms who were young and cute and wore Capri pants and made things like frozen chicken pot pies for lunch. They had color television sets before anyone else, and the girls almost all had fashionable clothes from Dayton's even in grade school. Once you were a Jefferson kid, you were always a Jefferson kid all through high school. It was a privileged and prestigious identity.

Kristin Machacek Leary grew up at 216 Twenty-First Avenue South with her parents, Leonard and Janice. She attended Jefferson from 1975 to 1981 and shared her childhood memories for this new history:

> *Jefferson Elementary was a "community within a community." Our section of town had all that one needed for an amazing childhood—a great school and fun areas to explore with special friends.*
>
> *As Jefferson Jaguars we remember…*
>
> THE TEACHERS AND SCHOOL STAFF
> *The teachers and staff were our neighbors, parents, and friends. They took pride in raising us, and it didn't stop when we went to junior high; it lasted a lifetime.*

A Brief History

Our teachers had the unique ability to bring out the best in each of us and made learning fun. Miss Kinsey's teeter-totter in the kindergarten classroom was the place where many friendships were formed. Snoopy's Dog House in Mrs. Chelsvig's first grade classroom was where many read a book alone for the first time. Mr. Boitz had the unique ability to teach math that we all could understand. And each year, he would take the fifth grade classes on a bus (that he drove) up to the Iron Range to see the working mines (round trip, in the same day, with several patient parents chaperoning). If you had Mrs. Loney, chances are that you still can recite the Gettysburg Address. Mr. Bambenek was committed to making sure that we were fit through the annual President's Physical Fitness test and school track and field contests. Not many kids can say that they had live animals in their classrooms. Mr. Johnson let us raise chicks and take them home for the summer, and Mr. Hammit had a pet snake. Our principal, Mr. Perkins, was special for many reasons. As kids we remember trick-or-treating at his home up in the "horseshoes" because he gave out full size candy bars.

Our school's PTA (Parent-Teacher Association) was incredibly active, and they were passionate about it. As children, we loved how they hosted the annual school carnival, where we had a haunted house, cake walks and an assortment of games.

Exploring, Playing, Ice Skating and Sledding

We were young explorers. We went everywhere on foot or on our bicycles, near and far. We had hills and plenty of them. We would be out all day exploring the hills, surrounding fields and the streets of Tangle Town where everyone else in town seemed to get lost. From time to time, we'd cross borders to swim at Northview pool or go to the stockyards during rodeo time.

We would play endless games of sand-wood tag on the "new playground." And when we needed a break from the playground we'd visit the South St. Paul Public Library bookmobile at the top of the hill.

Since we didn't have cellphones to notify us when it was time to come home, our mothers would yell for us, flash house lights or ring others' homes in the area to see if we could be found.

When it got dark, we would be out once again—this time, making our way up to the horseshoes for the nightly games of ditch during the summer. Many first kisses were had while playing ditch!

Ice skating at the school rink or the pond was a highlight. We would bring our ice skates to use during recess or after school. We would spend hours playing hockey, crack the whip and imitating the moves of Olympic

figure skaters. And there was a constant thrill of sledding down "Dead Man's Hill" and dodging the deadly chain link fence.
Our childhood was filled with memories that have lasted a lifetime.

THE TRANSITION TO JUNIOR HIGH
When sixth grade ended, we were well prepared for the transition to junior high thanks to our teachers and staff at Jefferson and our "community" of neighbors. What we weren't prepared for was walking a long way to school that had some big hills along the way (especially on the way home).

While many kept their friends from Jefferson, friendship circles broadened to include students from the other schools. Yet, when you go back to high school reunions today, you will often find many of the Jefferson Jaguars together reminiscing about the special days gone by when we were the kids from Tangle Town.

Today, Oak Park continues to be a charming part of the city, although the homes are no longer the epitome of modern residential development with their small single car garages and aging infrastructure. Just as they do in neighborhoods all over town, however, Oak Park residents often pass their homes down to children and grandchildren, who continue to preserve the unique nature of South St. Paul's Tangle Town.

PILL HILL AND WATERLOO WEST OF HIGHWAY 52

Pill Hill

A particular stretch of land high on the bluffs overlooking the Mississippi River became one of South St. Paul's most elite and elegant neighborhoods. Identifiable today as the 300 and 400 blocks of Fifth Avenue North, the property was first purchased by Chester Pitt in 1857, who most likely bought the forty-acre plat as an investment. The first homes on what was to become Fifth Avenue North were built in the early 1930s and the last were completed before the end of World War II. Each house is distinctive in design, although several reflect America's fascination with Spanish architecture that was prevalent at the time. Whether by intent or accident, several South St. Paul physicians were among the early owners of the Fifth Avenue homes. Their shared profession led to the street's nickname of "Pill Hill," a designation

that identifies similar neighborhoods of elegant homes belonging to doctors in Chicago, Illinois and Rochester, Minnesota.

South St. Paul's Pill Hill was home to Dr. Harold Tregilgas and to Drs. Earl and Thomas Lowe, brothers who shared an office on Concord Street. Local dentist Dr. Thomas Conlon moved onto the avenue in later years, as did Dr. Robert Lindell. Dr. Robert Forsythe, a veterinarian, was one of the owners of the plat in 1928 and lived at 389 for many years. One of the first houses completed was that at 379 Fifth Avenue North, which was the first home that Harold Stassen and his new bride, Esther Glewwe Stassen, built in 1932. They lived there when Harold was elected the governor of Minnesota in November 1938, making the house the only "Governor's Residence" in the state at that time. The home was purchased by William Bowen, owner of Lee Livestock, when the Stassens moved to their new house on Stewart Lane in South St. Paul in 1941.

Other residents over the years included the families of Union Stockyards sales executive Thomas Lesch, Campbell Commission Company salesman Myron Grant, Armour's cattle buyer Ewald Peterson, insurance agency owner Leo Rolle, Northwest Airlines executive Adolph Rindfleisch, Standard Building Supply owner Joe Chalupa and Southview Country Club founder Ezra Lloyd. Many of the homes were passed down from parent to child to grandchild over the years, and most have had only two or three owners in the seven or eight decades since they were built.

The most remarkable characteristic of the Pill Hill neighborhood is the view many of the homes have of the Mississippi River. Because of the height of the bluff and the angle of the hillside, most of the buildings on Grand Avenue and Concord Street are hidden and only the river, the barges, the tugboats and the pleasure craft are seen from bay windows and front yard patios. Today, the street is home to a close-knit group of neighbors, many of whom are completely new to South St. Paul but have come to appreciate the rich heritage and history that their homes reflect.

Waterloo West of 52

By 1960, South St. Paul was platted and divided into forty-foot residential lots and commercial areas from north to south and east to west. There were just a few acres on the far north end of the city that were still dedicated to farming. It was a lovely spot where fruit trees and berry bushes grew to maturity on the gently rolling hills that formed the city's border with West St. Paul.

One of the prominent families of this part of South St. Paul was the Brotzler family. Jacob Brotzler married Margaret Leidig at the Salem Evangelical Church in Inver Grove Township in 1892 and soon purchased a farm on Butler Avenue at South St. Paul's north end. The house sat high on a hill overlooking acres of flowers and berry bushes that spread their way to the Mississippi River on the east. Jacob hauled the family's water from the lake at Thompson Park. Trained as a landscape gardener in Germany before coming to Minnesota, Jacob was one of the designers who created the "Gates Ajar" floral sculpture at St. Paul's Como Park.

Jacob and Margaret Brotzler had twelve children, ten of whom lived to adulthood. Two of their sons, George and Charles, settled on land in the same area as their parents. Charles raised vegetables and root crops while George grew strawberries, raspberries, currants and gooseberries.

These families of the northern neighborhood were dismayed and concerned when plans for Highway 52 began to be discussed in the early 1960s. Officials felt it was important to alleviate traffic on Robert Street and wanted to add another bridge across the Mississippi River to the east of Robert. The residents of South St. Paul's last farmland north of Butler were told that their homes were being condemned. They were given the option to buy their own homes back if they wished to move them to new locations. They were given 120 days to make a decision. Some residents chose to walk away with the market price for their property, and their homes were torn down or moved.

Others, like Gladys Brotzler Rosvold, the youngest of George Brotzler's children, and her husband, Don Rosvold, moved their home just a short distance to the west in order to keep their lovely house from destruction. A new home was to be built for Gladys's parents on what was to become Waterloo Avenue, but sadness lay in the fact that the family's original home, built in 1928, was not moved but completely demolished by the state to make way for the freeway.

The other loss that produced sorrow was the complete destruction of the wild woodlands where more than twenty magnificent ancient oak trees were destroyed in one day even as the orchards and berry plots were graded into nothing more than cavernous sites for asphalt roadway. The beautiful and natural pond on Waterloo was filled and eliminated as a wetland space. The area was also the site of ancient burial mounds established by the ancestors of the Mdewakanton Dakota people who had settled in the area generations before the freeway plans became reality. Arrowheads and evidence of early residents were common finds during the Highway 52 construction.

A Brief History

The development of the freeway created an interesting and odd twist in South St. Paul's city border definitions. There are only twenty-some homeowners on the west side of Highway 52 who are residents of South St. Paul.

Current South St. Paul residents travel Highway 52 dozens of times each week and perhaps cannot imagine the city without that major traffic artery. Still, it could be meaningful to pause for a moment, look up at the bluffs on the freeway's west side and remember the rolling farm fields and beautiful berry bushes that were once part of the Brotzler family estate.

7
The End of an Era

In order to capture the atmosphere and experience of old South St. Paul, I'm sharing another story from Jim Servatius about growing up on Concord Street.

My parents, Bernard and Virginia Servatius, moved to South St. Paul in 1942, seeking steady work and a better life than what they had in the small town of Melrose, Minnesota. They brought everything they owned on a two-wheel trailer and had only a few dollars in their pockets. Times were hard for everyone during and after World War II. My dad was a mechanic by trade and soon got a job as a motorcycle mechanic at the Harley Davidson dealer in St. Paul. Dad worked in the mechanic trade his entire life.

My sister Gail was born in December 1942, and I came along in January 1944. We lived in a two-room rented apartment at 211 South Concord Street, right in the midst of the commercial/industrial district of South St. Paul. The streetcar tracks ran within twenty feet of our front door, and the railroad tracks were directly behind our house. Beyond the tracks were the St. Paul Union Stockyards, the world's largest stockyards, and the huge meatpacking plants of Swift's and Armour's. Besides the packing plants and the stockyards, there were dozens of supporting businesses that spanned from beyond Grand Avenue on the north to past Armour Avenue on the south. Many of these operations ran twenty-four hours a day so the din was never ending. Twenty-four-seven, there were cattle lowing, pigs

SOUTH ST. PAUL

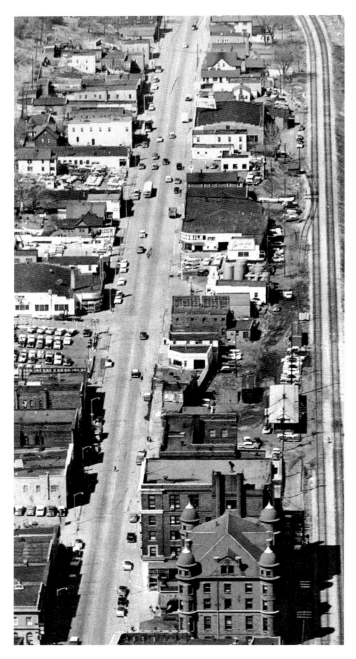

Today's newer residents could never imagine the kind of bustling city center Concord was in the heyday of the meatpacking industry. This photograph provides an overview of Concord looking north from Grand Avenue. *Dakota County Historical Society, Dave Petek, photographer.*

squealing and sheep bleating. Amazingly enough, it all seemed quite normal for the folks who lived there.

There was no end to the movement of trains and cattle trucks that were coming into town for delivering livestock to the stockyards. Identifying the independent cattle trucks became a hobby of mine as soon as I learned to read. They came from all over and each one was lettered with the owner's name and city of origin. It didn't take me long to memorize every one of them. I could even identify some just by the sound, even before they came in to view. These of course were the days before video games and computers so a little kid had to be creative with finding ways to entertain himself. In that regard, I never did have a shortage of ideas.

For entertainment, one only needed to sit on a bench in front of the house, as a never-ending cast of characters were always present. My neighbors were Fuzzy, Ziggy, Ikey, Pistol Pete and a guy called Murphy. We lived next door to a bar or, more accurately, a beer joint. In fact, about every second door on Concord Street was an entry to some sort of liquor establishment. A Shell Service Station was located across the street and a radiator repair shop was our next-door neighbor to the north. Beyond the radiator shop was a trucking company, and I guess you are probably getting the picture. For me, there was no end to the value of entertainment and education I was getting at a very young age. I had a lot of freedom to get around, as there were very few dangers facing kids like there are today.

Life could be rough, too, as there was no shortage of tough kids who were usually looking to fight someone. However, that did not deter me from going where I wanted to go, as one gets inured to it at a young age. There were many poor people in the neighborhood, and alcoholism was widespread. Consequently, many kids had little or no supervision, no money and nothing to do, which is probably why some of them were mean and rowdy.

By necessity I had developed a great imagination at a young age, so I always found something to occupy myself. I explored every square inch of Concord Street that I was allowed to go, plus a few places that I was not allowed to go. Those were always the most exciting for me, as I had already become a thrill seeker by age five.

I liked hanging around the numerous garages, auto dealerships and truck stops, as all of the things I was interested in were happening at those places. I usually kept my distance so I wouldn't get chased away, and after a while, people just got used to me hanging around and asking a lot of questions.

There was a wooded bluff that separated Concord Street from the hill district, and it ran the entire length of South St. Paul. Those woods were

my sanctuary, my refuge and my retreat from whatever I was retreating from at a given time. I was maybe one hundred feet from Concord Street but in my mind I may as well have been one hundred miles, as it allowed me to imagine a thousand scenarios as I conjured them up in my head. It was high adventure for a boy of six.

Motorcycles were a big part of the Concord Street scene, as at least two motorcycle clubs were based in South St. Paul. After the war motorcycling had become very popular, especially for the returning GIs who were looking for more thrills. I was lucky because my dad was a member of both clubs and just about every night of the week, the bikes were parked in front of our house while the riders were in the bar next door. I loved motorcycles so I was lucky to be in the midst of the action. As a matter of fact, our family vehicle was a Harley Davidson motorcycle with a sidecar on it, and our family rode it summer and winter. We were still a family of four but would grow to be a family of nine, so Dad eventually had to buy a car. Meanwhile, I enjoyed the fact that we didn't own a car. I should mention, no one ever complained about it being too cold to ride.

The Concord Street action never ended, as there was always something going on. The merchants on Concord Street always seemed to be busy, so restocking of merchandise was constant. The movement and unloading of the merchandise was done through grates in the sidewalks directly into the basements of the stores and bars. I never missed an opportunity to watch these fascinating operations from a safe distance; as for me, I was inquisitive so it was very interesting to learn how everything worked.

Many hobos rode in on the cattle trains coming in from the west because they knew the trains were coming to South St. Paul, the mecca of good paying jobs. However, there were always more applicants than there were jobs so many were left disappointed and broke. My mother fed many of the hobos who came to our back door looking for odd jobs. We never did have odd jobs for them but they never left without having a sandwich or a piece of fresh homemade pie. These men were not bums, but rather they were good men who were down on their luck, as so many were at that time.

Every day, I watched as thousands of people walked to and from work at the stockyards and the packing houses, as in those days, many folks only took their cars out on Sundays. These people worked extremely hard and were the mainstay of the community. Even at my young age, it was already apparent to me how important it was for adhering to a strong work ethic, and I saw it in my own father, as well. South St. Paul was a blue-collar

A Brief History

town in every sense of the word, and the people who lived and worked here were very proud to be a part of it.

Concord Street was a place filled with spirited lively excitement, good people and never-ending happenings. In those days, South St. Paul was the ultimate destination for shopping, purchasing a new car or having a good time. I would not trade my experiences of living there for anything and would not have desired to spend my early years anywhere but Concord Street.

Jim's memories of Concord Street bear no similarity to today's Concord neighborhood. Until the mid-1970s, what is today known as Concord Exchange was Concord Street. The four-lane Concord Street that we know today was where the railroad tracks had been since 1886. Grand Avenue led right into the Swift & Company entrance and Armour Avenue ran between the Armour gates, which still stand on the site. Today's Concord Exchange once bustled with cars, trucks, shoppers, deliverymen and the kids and characters mentioned by Jim in his story. Boardinghouses and businesses were built on backyard lots heading up to the bluff, creating a maze of dirt walkways and addresses like 137½ South Concord, where the "half" was the backdoor of the building behind the main building on Concord. Some of the main buildings, like the Stockyards Exchange, the 1930 Federal Post Office and Drover's Bank, were excellent examples of early twentieth-century design, but others were wood-framed, rundown old tenements for which fire was an ever-present danger.

Businesses and boardinghouses, apartments and private homes were built almost on top of one another, creating a maze of paths that made it difficult to identity a specific address. This photograph was taken during the 1965 flood. *Author's collection.*

South St. Paul

This group of buildings was spruced up for the Great White Way project that removed the streetcar tracks. Drover's Bank was on the corner to the left, and then the structures were Page's Café, the South St. Paul Chamber of Commerce Office and Bob Corneia's Motor Parts Service. This was the scene across from today's South St. Paul Post Office. *Reinhold O. Werner photograph collection.*

As the post–World War II years brought a boom in babies and building of new residential properties, city leaders also wanted to put a shiny new face on Concord Street. One of the first steps was to usher in what was called the "Great White Way" in 1952 by tearing up and removing the streetcar tracks on Concord and replacing the old-fashioned historical light poles with bright new street lights. Businesses along the main street spruced up their façades, added new signage and cleaned up the sidewalks in an effort to make South St. Paul look modern and welcoming.

Ten years later, in 1962, civic and business leaders often found themselves frustrated with the limited space that South St. Paul had for retail and industrial development. No matter how bright the streetlights, the railroad still ran right through the Concord corridor and the noise and smells of the livestock pens across the tracks were an ever-present reminder that the city had been around for seventy-five years and simply couldn't compete with the kind of retail and restaurant boom that neighboring West St. Paul was experiencing on South Robert Street. There was a serious lack of parking,

and Concord Street was built up pretty much end to end with old buildings, some of which had been refaced, rebuilt, remodeled and renovated, but many were deteriorating.

Saddle City and the Concord Street Urban Redevelopment Plan

The South St. Paul Chamber of Commerce presented a concept plan at its February 1963 Annual Meeting. Rollin Glewwe, chair of the Saddle City Committee of the Chamber, displayed charts, graphs, maps and pictures of a newly imagined city where the businesses on the hill were connected to Concord Street by creating a split level development that would utilize a system of ramps, escalators and other facilities, making it easy for people to shop and park in both areas.

The plans included modernization along the west side of North Concord Street south of Grand Avenue, construction of new and modern storefronts on Pitt Street for shops, a possible civic center to the east and south of the library and a YWCA with an indoor swimming pool. Glewwe made it clear that the development would require cooperation and partnership of existing business owners and financial institutions to create the incentives and interest rates that would encourage large scale investments in the concept. The committee had also considered the land to the east of the proposed Waterloo Freeway (now Highway 52), where a large retail and industrial area could be developed.

According to the press coverage at the time, the concept was greeted with enthusiasm and the Saddle City Committee was directed to come up with specific proposals and prices for various aspects of the exciting new development.

That same summer of 1963, a group of local business owners, civic leaders and elected officials came together as the Community Redevelopment Committee to finalize a specific plan for future growth. Known as the Committee of 40, the group, all white men, was headed by attorney Arthur Gillen. In 1964, South St. Paul became the first Minnesota city outside St. Paul and Minneapolis to form its own Housing and Redevelopment Authority. The new HRA and the Community Redevelopment Committee worked for years to prepare a recommendation, which came to the South St. Paul City Council for approval on November

25, 1968. The HRA had received $3.1 million for urban renewal along Concord Street in 1967, and the Concord Street No. 1 Urban Renewal Project was officially adopted by the city council.

Swift & Company Closes

The city was poised for development but then on November 29, 1969, Swift & Company closed its South St. Paul meatpacking operations forever. Was it a surprise? According to Swift's officials at the press conference where the announcement was made, they had been experiencing serious losses at the South St. Paul plant since 1959. They calculated that they had only 2,400 jobs still left at the company, 1,900 hourly and 500 salaried. Workers were perhaps less surprised than the general public. For years, cost-cutting measures had led to reductions in hours and a slowdown in moving people to permanent full-time positions. Hourly employees could be let go on a moment's notice, and production levels were dropping every year.

The 1948 strike had revealed many problems within the meatpacking industry, and although the United Packinghouse Workers Union had grown over the years, it was becoming clear that it was no longer cost efficient for livestock growers to ship live animals hundreds of miles to the South St. Paul or Chicago stockyards. Instead, smaller packers began opening up or expanding their facilities closer to the growers throughout the Dakotas and southern Minnesota. Plants like Hormel in Austin had remained small enough to efficiently install new packaging equipment and production systems. They produced the one billionth can of Spam in 1959, just as Swift & Company began having production problems in the sixty-four-year-old local plant.

Demolition and Dreams of Renewal

Despite the loss of Swift's, urban renewal plans proceeded between 1969 and 1975. Although 136 buildings were eventually demolished on Concord, Grand, Pitt and the other side streets that connected to the main thoroughfare, it was the relocation of the railroad and the creation of the four-lane Trunk Highway 56 through the city that made the most dramatic

A Brief History

and irreversible change. In 1972, when the railroad project received funding, the theory was that the relocation would open up completely new space for large retail and industrial development while providing a new and attractive modern entrance to the city. Millions of dollars were spent to remove the tracks that had been in place since 1884 and move them to the west bank of the Mississippi River. Nearly the entire Swift & Company complex was demolished and hauled to the north end, where it was dumped into a hastily created landfill that today is the site of the Kaposia Landing dog park and ball fields.

The new four-lane highway that was intended to bring new shoppers to town actually provided a nonstop thoroughfare for potential visitors to zip right past South St. Paul and never look up. The former Concord Street hub of the city was renamed Concord Exchange, and the massive demolition cleared block after block after block for potential new development. Now, with Swift & Company gone, the demolition of the dozens of buildings that had housed the plant opened up acres of property between the new Concord Street and the riverfront railroad tracks.

By the late 1970s, a program called Voluntary Emergency Acquisition Program, or VEAP, made it possible for the HRA to acquire substandard

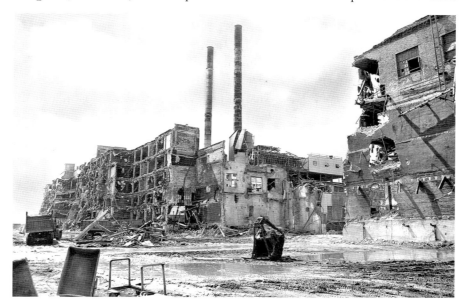

The Swift & Company plant was torn down in 1971–72 and the debris was hauled to Port Crosby on the north end, where it was used for landfill on what is now Kaposia Landing. *Fred Grant, photographer.*

homes along North and South Concord Street and to open up several new areas for commercial development, especially at the junction of Concord and I-494.

As the wrecking ball continued its progression along Concord Exchange, decisions were made to save the Exchange Building, the adjacent Stockyards National Bank and the office building that today is Globe Printing and Office Supplies, founded by Ed Horst in 1955, and moved to its current location in 1973. Ed's sons Dan and Bill Horst and Bill's son Mark own and operate the business in 2015. The federal post office, built in 1930, was preserved, as was the basic structure of Drover's Bank on the northwest corner of Grand Avenue and Concord Street across from the Exchange. It was, however, remodeled and a new marble façade soon covered any evidence of the landmark corner clock and the brickwork of the original structure when Cenex, formerly Farmer's Union Central Exchange, moved its administrative offices to the site. The Swift & Company Shippers Club was salvaged, as was another Swift's Building at 135 East Grand Avenue and the former Swift & Company lab building east of the Shipper's Club. A few bars and restaurants at Armour Avenue and the new Concord Street were salvaged, including the Lincoln Hotel, later known as the Buckboard; the GFN; Paape's Corral; Nick's Tavern; and Uncle Louie's Restaurant.

Beyond those few landmarks, almost everything was gone. In July 1977, the Stockyards Exchange Company moved to a new building on the former Swift & Company property, abandoning the grand old Exchange Building for more modern offices. A few of the businesses on North Concord survived, including the corner bars and shops in the old Bryant Block building in South Park. Fury Motors and Willis Bee Line were untouched, and Betty's Café next to the Willis shop remained in business until Betty Frances Marguth Harren passed away in 2004. Ries Electric and a handful of individual apartment buildings also escaped the wrecking ball.

For some, the removal of the often rat-infested old tenements and bars was a breath of fresh air as they anticipated the establishment of a brand-new business district bustling with commercial, retail and entertainment spots. For others, the demolition was a devastating blow as, one by one, the businesses they'd known and supported for years were destroyed.

The original plan had been that the HRA would help the dislocated business owners rebuild new facilities, and everyone would turn out to benefit from the massive vision for tomorrow. Unfortunately, that didn't always seem to be the case. Protest posters from disgruntled property owners adorned the storefront windows along Concord, and to the present day, any inquiry into

A Brief History

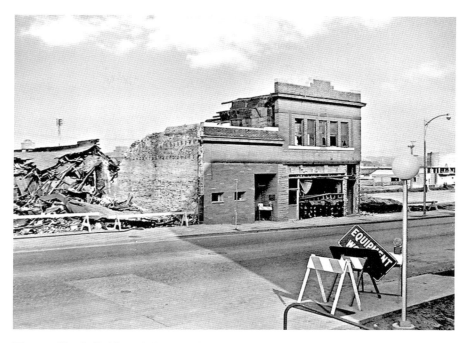

The wrecking ball ultimately brought demolition to 136 buildings along Concord, Grand, Pitt and other side streets. This photograph includes the destruction of Sweeney's, Nick's and the Hook-Em Cow bars. *Fred Grant, photographer.*

the redevelopment era in South St. Paul often prompts accusations about how former business owners were offered less than their properties were worth and how their protests were ignored. Still others had been operating businesses for years and were simply ready to retire to Florida or Arizona and let the city sort out the redevelopment dilemma.

While all of this demolition was happening, the HRA was also involved in enhancements in senior and low-income housing, which was another of its stated directives. The Nan McKay high rise, built in 1969, was named for the first executive director of South St. Paul's HRA. It opened on Marie Avenue with 132 apartments, and in 1974, a second high rise of 166 apartments was built and named for John E. Carroll, one of the early presidents of Farwell, Ozmun and Kirk, which had come to town and built a new building on the former Swift & Company property. Carroll was also instrumental in bringing the Waterous Company's new international headquarters to the former Swift & Company site, and Grand Avenue east of Concord was renamed John E. Carroll Boulevard in 1974 in honor of Carroll's involvement.

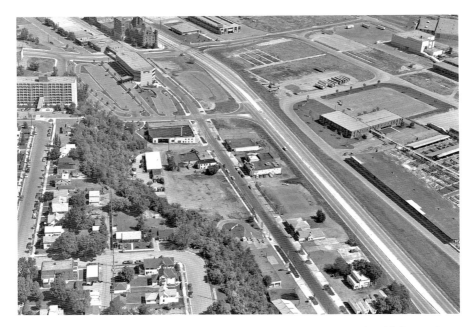

The new four-lane Concord Street replaced the old railroad tracks and the old Concord Street became Concord Exchange. This is the view of the new landscape following demolition of most of the businesses. The Exchange Building is at the top of the photograph across from the then new Northwestern Bank Building. *Fred Grant, photographer.*

The passage of the Housing and Community Development Act of 1974 by Congress made it possible for the city to embark on a five-year plan, which created many improvements in the city's deteriorating areas: parks and playground development, Central Square, street improvements, Hill Business District improvements and extensive housing rehabilitation activities.

New businesses had begun to build modern facilities on the areas opened for development. Northwestern National Bank built its new building on the southwest corner of Concord Exchange and Grand Avenue and brought the city its first and only skyway connecting the new bank to the renovated Cenex office building across Grand Avenue. In 1973, Mike Leitch, who had owned and operated the Hillside movie theater on Grand Avenue, built a new movie theater with two screens, known as South I and II at 333 North Concord. Country Club Grocery built a new store on Concord Exchange, where Royal Star Furniture is in 2015, and Wells Fargo Lanes, now Mattie's Lanes, Sports Bar & Grille, opened a new bowling alley, bar and restaurant north of the movie

theater. Dakota County dedicated a brand-new museum and research library on the corner of Grand Avenue and Third Avenue North as the new home of the Dakota County Historical Society in April 1978. As mentioned in the stories about neighborhood development, building was booming all over the city during this period of urban redevelopment on Concord and Grand. South St. Paul was positioned to head into a successful future, and although the new plan was a far cry from the early Saddle City concept of 1963, over $10 million had been invested into the city from federal grants. The vision for tomorrow looked promising.

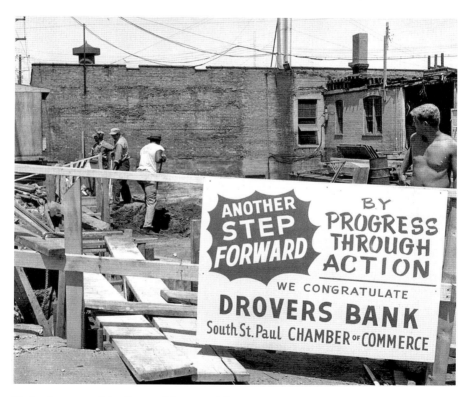

Redevelopment of the Concord Street and Grand Avenue area was a controversial project from the very beginning. Many found signs like this one offensive because it didn't seem that progress was actually being made. *Dakota County Historical Society.*

The End of Armour's

As these first redevelopment efforts were beginning to take hold, Armour & Company shut down what was once the largest and most modern meatpacking facility in the country on June 13, 1979. The company had been purchased by the Greyhound Corporation, and the equipment was obsolete and unable to be replaced at a reasonable cost. It was never specifically reported exactly how many jobs were lost, but newspapers of the time indicate that Armour's had four thousand employees. Like Swift & Company, the plant had gradually been reducing hours and moving people into part-time rather than full-time positions for years. They had closed the beef kill operation in 1973, and now the entire operation shut down. Between the two plants, the livestock industry had at one point employed over twelve thousand people and now, with the closing of both plants, those jobs in the stockyards company, the auction barn, the commission firms, the banks, the insurance companies and the cattle brokers had all declined.

In 1981, Mike Kassan, the irrepressible developer who had brought the city Oak Park, Blandings' Dream House and new residential developments like Kassan Court, purchased the entire forty-seven-acre Armour's site. He renamed it Armour Place, put up banner entrance signage and began renting out space to a variety of businesses willing to move into the old plant. Discussions took place among civic and business leaders across the spectrum. Could the old plant become a hotel/casino/entertainment complex? Was it possible to turn a five-floor slaughterhouse into a historic landmark that would secure South St. Paul's future?

Despite Kassan's optimistic efforts, South St. Paul was designated an economically depressed community in the early 1980s, which qualified the city for federal Economic Development Authority (EDA) Funds after the city established a local EDA. With that group promptly organized, volunteer commissioners were appointed to represent all segments of the community. During the same period, concerned local businesses and residents formed South St. Paul Futures, a private organization that assisted the city, HRA and EDA to encourage development and job creation through various funding programs. A few businesses worked successfully with the various agencies to obtain funding to build new facilities in the newly cleared development area. The HRA also continued to implement its mission of providing low-income housing by building forty-four family town homes on Camber Avenue in June 1982.

A Brief History

Things didn't always move forward as planned. In January 1980, vandals broke into the old Exchange Building and turned on the sprinkler system, which flooded the building for several days before anyone noticed a problem. Many of the historic tin ceilings, the electrical system and much of the heating and ventilation equipment were destroyed. No one was ever charged with the crime, but the building, which had been placed on the National Register of Historic Places in 1979, had become vulnerable, and murmurs began to circulate about tearing it down. Colonial Properties had brought a proposal to the city council prior to the flood to develop the building into office and restaurant space, and the city had approved it. Before the deal was closed, however, Morris Kloster took over the property, meaning he was the owner of the damaged structure. In 1985, the HRA built a two-level parking ramp across Concord Exchange from the Exchange Building in an effort to attract potential new buyers.

Mike Kassan also realized that the cost of redeveloping the former Armour's plant into any kind of re-use would require millions of dollars, not only to turn the slaughterhouse into acceptable space, but also to clean up the land that had been polluted for years by the various chemicals, fuel oils, paint and other substances that remained in the soil across much of the forty-seven-acre site. In November 1987, the HRA offered to buy the property from Kassan for $1,050,000, subject to environmental studies, PCB contamination and asbestos removal. Six months later, the Greyhound Corporation, which owned Armour's, finally agreed to clean up the site, and the purchase closed on July 22, 1988. The HRA relocated the twenty-two tenants who remained on the site and began to make plans for demolition and site preparation.

Rebuilding Community

For a city like South St. Paul, where generations of families are interrelated and where traditions and customs and habits are ingrained for decades, change is often not only difficult but also often unsuccessful. It is also a challenge to speak for or attempt to summarize how people of the past were feeling and thinking. The closing of the city's two major employers, the demolition of 136 buildings and the resulting economic devastation impacted people very differently. For the HRA, the EDA, South St. Paul Futures and elected officials, federal money and assistance was helping to

sustain a sense of optimism. For others, like the families of people who had lost their jobs or former packing plant workers who had lost their identity and the daily interaction with friends and co-workers, it seemed as though the city had lost its heart and soul and would never recover.

Darrol Bussler came to South St. Paul in 1972 to teach high school English. He was laid off in budget cuts three years later but returned when then assistant superintendent of schools, Dave Metzen, asked him to accept a new position with the ABE/GED program within the Community Services Department of South St. Paul Public Schools. One year later, the director of what we know now as Community Education resigned, and Darrol was promoted to the director position.

Bussler recently shared his memories of those early days. Reflecting on the loss of the plants, declining school populations and the demolition of downtown, he wrote:

> *The laughter of farmers, truckers, stockyard and meat packing workers fell silent…and eventually, a deafening silence hovered over South St. Paul. Its heart had been ripped out. Why would anyone come here? The silence was evident in meetings, especially school board and city council meetings. When elected leaders were forced to face the facts of trying to maintain what existed with fewer and fewer dollars, meetings often became think tanks, sometimes filled with moments of sad silence. The only public gatherings of people in the community were school board and city council meetings; in most meetings there was no joy.*

It was this community silence and sadness that prompted Darrol to create the first Christmas in South St. Paul celebration, which debuted in December 1975. He recruited volunteers from the churches, businesses and schools, as well as the city's Civic Arts Commission, and began a tradition that lasted for decades. While the South St. Paul Male Chorus and the Choralettes provided the musical foundation, the productions also included a variety of art forms with instrumental music, dance, theatre, visual arts and spoken words. Even the elegant and elaborate printed programs were designed to evoke memories of community for years to come.

Only days after the first Christmas in South St. Paul event, Darrol was approached by Bob Verkennes who asked Darrol why they couldn't do a similar kind of community building event in the summer. The South St. Paul Jaycees traditionally put on a Fourth of July fireworks show, and eventually, it was suggested that some events could be added to the Independence Day

A Brief History

The first Kaposia Days celebration was held in 1976, the brainchild of Darrol Bussler, community education director. It was an effort to bring the community back together with some sense of joy, unity and optimism for the future. The annual event commemorated forty years in 2015. *Author's collection, Dave Petek, photographer.*

holiday with the fireworks as the culmination of a city celebration. The name Kaposia Days was chosen, and a parade and kiddie carnival were planned. Darrol described the first event as also including

> *a Children's Parade, Evening in the Park (food, music, theatre: Chimera Theatre, St. Paul), Art Show, Craft Fair, Family Races, Outdoor Stage Show (high school stadium), and an unveiling of Bicentennial art at City Hall, executed by community artists: (1.) An exterior Minnesota design by Robert Zins. (2.) An interior historical clay relief by Betty Thompson, on a stairway-landing wall. And in recognition of the Bicentennial, a forty-page booklet was printed, describing the events and including "South St. Paul—Now and Then," a history with photos written by J. Robert Stassen. Funding for this booklet and some of the events was secured through a grant from the National Endowment for the Arts...Along with the Jaycees Fireworks, there was one event that set the tone for the following year: A street dance in the parking lot of Northwestern National Bank, located on Grand and Concord. The setting was perfect, with the sunken parking lot full of dancers under evening lights, a band playing on the drive-through*

above, and people seated on the hillside and parking lot edges, enjoying a soft, summer night. A comment was heard: "I never saw this many people together in South St. Paul before." It was a community event with every age, social class, community group and organization represented: city, school, faith, business, and service. There was laughter and shouting. It was a positive public gathering of the community. And once again, there was life on Concord Street—echoes of laughter and shouting from an "open, friendly community" of days gone by. The following evening, the Outdoor Stage Show, playing before an audience in the stadium, came to a culmination with the future Miss America, Dorothy Benham, singing "Happy Days Are Here Again."

So it began. Darrol Bussler and Superintendent of Schools Dave Metzen brought sustainability to concepts like Kaposia Days by also creating South St. Paul Community Partnerships. This was a group that had representation from the city council, school board, chamber of commerce, local businesses, civic volunteers, community organizations, South St. Paul Police and Fire Departments, elected officials, the Centennial Commission and other interested citizens. Meeting regularly, Partnerships was an ideal forum through which to sound out ideas and visions, promote events and provide everyone an opportunity to discuss, raise concerns and resolve issues in a positive and proactive way.

But rebuilding a community's identity, pride, sense of self and optimism is a long and uphill process. For every smile and laugh, there were other complaints or criticisms. By Kaposia Days 1986, ten years after the festival was founded, there were still long empty blocks of open space along the old Concord Street. The abandoned Armour plant still stood vacant and falling down next to the remaining, sometimes broken-down or no longer used open wooden holding pens of the Stockyards Company. While the auction barn continued to echo with the auctioneer's distinctive calls, the number of livestock coming through was nowhere close to where it was twenty years earlier.

Like Darrol Bussler, I came back to town at a time of transition. I was hired by the city to plan and implement a series of events to celebrate South St. Paul's 100th anniversary in 1987 and by the South St. Paul Chapter of the Dakota County Historical Society to take the hundreds of photos and stories they'd gathered over the years and pull them together into a huge history of the city. I'd been gone for nearly twenty years, first living in Minneapolis while attending university and then, for fourteen years, going to graduate school and working in Philadelphia, Pennsylvania. One of the first things I

had to do was adjust to seeing a city I'd never seen before. When I left for college, Concord Street was still bumper to bumper with traffic, the packing plants were both in full operation and bars and businesses were thriving.

I drove down Grand Avenue and into the yards, entering where the Swift & Company property used to begin. I turned right onto the old Chute Road and was confronted by the sight of a dead, bloated hog right in the middle of the street. I couldn't help but feel a sense of total dismay. What in the world had happened to my hometown? I turned around, not needing to see any more. For the next few months, people brought me photos and stories for the history book. They'd sit across from my desk in the basement of city hall, and more often than not, they'd end up in tears as they told me how much they missed their friends, their jobs, the businesses and the bustle of the old downtown. There was that same sense of despair in the air that Darrol Bussler sensed years earlier. Bussler mentioned in his recent reflection that it was his naïveté that made it possible for him to move forward with Christmas in South St. Paul and Kaposia Days. I was also naïve. I'd been hired to tell a story and plan a party, and that's exactly what I did, with the outstanding help of hundreds of volunteers.

Fourteen thousand people attended at least one of the events at the centennial celebration of the All-Class, All-City, All-Family Reunion in August 1987. This photograph was taken at the Reunion Dinner at Wakota Arena before that night's street dance in the Northwestern Bank parking lot on Grand Avenue and Concord Street. *Dakota County Historical Society.*

Over the course of twelve months in 1987, the South St. Paul Centennial Commission presented the community with over twenty major events, including a Hook-Em Cow revival during the St. Paul Winter Carnival, a city birthday party with the councilmembers in historic costumes, the completion and ultimately five printings of the centennial history, an ethnic festival and bringing back a 1937 South St. Paul fire truck to join the Kaposia Days celebration. In August, over fourteen thousand people attended at least some of the events of the All-Class, All-City, All-Family Reunion weekend. A four-hour cable television series called *Mysteries of History* was produced and shown locally for months, and in the fall, the Otto Bremer South St. Paul Hall of Excellence was dedicated at Central Square with fifty charter members. That forum continued for another ten years with photographs and biographies of each year's inductees added to the exhibition. As the centennial year progressed, more and more people seemed to show up at every event. There were two local weekly papers at the time, the *South St. Paul Sun-Current*, which was a direct descendant of the former *South St. Paul Daily Reporter* that had been founded in South St. Paul in 1891, and the *Southwest Review*. Along with the two metro dailies and Town Square Television, the local cable producer, South St. Paul received outstanding press coverage that helped promote not only the public events but also the availability of land for development in the city.

REAP Is Born

In November 1987, as the centennial celebration drew to a close, South St. Paul was selected as the site of a visit from the Governor's Design Team. This was a group of volunteer architects, city planners and landscape designers who came to town for four days. They lived with local families and spent every waking hour touring, traveling and talking their way through the city. A series of meetings were arranged for team members to meet with the chamber of commerce, city officials and other groups. Their work culminated at a town meeting where they unveiled their vision for what South St. Paul could become. Included were a connecting cultural corridor to bring the shopping districts on the hill together with the new Concord, redevelopment of the Exchange Building into a dramatic showpiece, opening up of the riverfront by demolishing the Armour plant, improving Kaposia Park trails and facilities, enhancing public art and creating a

publically accessible river trail along the Mississippi River through the city. They suggested that a nonprofit organization be formed to coordinate all of these efforts. Once again, Darrol Bussler brought his creativity to the table, and the River Environmental Action Project, or REAP, was born.

The final event of the year was the Centennial Ball on New Year's Eve in the great hall at the Dakota County Historical Society. Hundreds attended, decked out in historic costumes, to watch an ongoing slide show of images from the past year and to share ideas and visions for the future. Longtime residents, elected officials, new young families and excited volunteers were together again to begin a new voyage and put an end to the sad silence that had prevailed for so long.

8
Reclaiming the River

The operative word in the new nonprofit that was created out of the Governor's Design Team visit was "River," as in the River Environmental Action Project. On February 4, 1998, the group formed eight subcommittees called Action Teams to guide the work of each major area. The teams were: Pedestrian Walkway (River Trail), Marie Avenue Connector, Kaposia Park Connector, Memorials, Armour's, Marina, Natural Environment and the Exchange Building. In some ways, it was as though a spark had been lit and developments began to happen quickly and dramatically.

In January 1988, Lancer & Associates presented a proposal to the city to purchase and renovate the Exchange Building into luxury condominiums. They would preserve the original woodwork, the tin ceilings and the unique ceramic fireplace fronts that were in place since the original 1886 construction. Morris Kloster still owned the building but in Lancer's case it was a matter of zoning as housing was no longer a permitted use on Concord Street. The project eventually received approval of the city council, but Mayor Bruce Baumann vetoed their decision. In a dramatic council meeting held in April 1988, hundreds of citizens packed the council chambers and the hallways of city hall as the council voted to override the mayor's veto. The brouhaha over the project unfortunately scared off Lancer's investors, and the proposal was withdrawn in December 1988.

Then in February 1989, Katherine Trummer, who had been elected to the city council for a four-year term in 1987, decided to file for the mayor's position, challenging Mayor Baumann. Along with Katherine, Joe

Kaliszewski, I and nine other candidates took the bait and filed for two open seats on the council. When the election was held in April 1989, Trummer, Kaliszewski and I were all elected, and a few weeks later, we were successful in seeing Nick Motu, the next-highest vote getter, appointed to the council to take over Katherine's remaining two-year term.

REAP held the first Mississippi River Cleanup in South St. Paul on April 21, 1989. Hundreds of bags of trash, old appliances, tires and metal scrap was loaded onto barges donated by Packer River Terminal and hauled to the recycling site. Two weeks later REAP appeared before city council to request that they meet with the Department of Natural Resources to request the establishment of a public boat launch in the city. On June 3 of that year, REAP held the first Eagle Watch in Grandview Park, celebrating the return of eagles to the Mississippi River flyway in the city. Public tours of the Port Crosby site were held after the event. Port Crosby was a multi-acre site at the north end of the city on the riverfront. It was owned by American Hoist and Derrick and Canal Capital Corporation. The HRA approved use of $7 to $13 million in Tax Increment Financing for infrastructure on the site, and REAP, the city and local legislators began efforts to obtain a public marina permit from the legislature.

On June 1, 1989, demolition of the old Armour's plant began with a ceremony at the Armour's office building as Mayor Trummer swung the mallet symbolizing the project, and that September, the first conceptual drawings of the new river trail were unveiled at a REAP town meeting. In July 1989, Minnesota state senator Jim Metzen called a meeting with REAP, City Parks and Recreation director Randee Nelson and Minnesota state representative Bob Milbert to work out a strategy to obtain funding for the South St. Paul River Trail by having it named part of the Dakota County Regional Trail system. Milbert and Metzen obtained that designation and funding through the legislature in 1990. Everything that happened on the riverfront became significant in these years as hopes arose for legal public access.

Not everyone, however, considered the river to be off limits. Paul O'Brien spent his childhood on river long before cleanup efforts had begun. He recently wrote:

> *As a teenage boy, growing up in South St. Paul in the early/mid-1980s meant in the summer, you didn't spend the day in your buddy's basement, playing video games all day. Your parents wouldn't allow it, and the technology didn't exist anyway. So you actually went outside and did things*

A Brief History

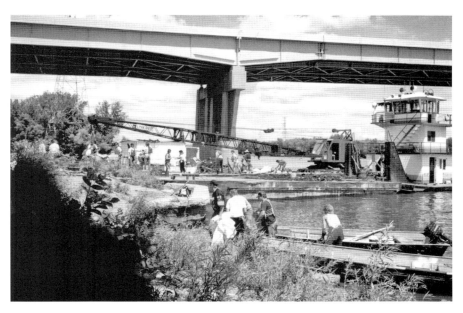

The first Mississippi River Cleanup was sponsored by REAP on April 21, 1989. Hundreds of pounds of trash, including appliances, tires and garbage, were collected and bagged by volunteers. It took barges to haul the collected trash away. Within a few years, as public access to the boat launch and river trail was achieved, the amount and types of trash collected each year decreased significantly. *Author's collection.*

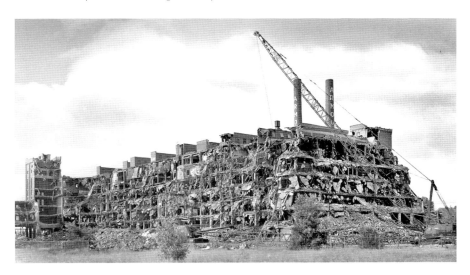

The ceremonial first swing of the wrecking ball at the old Armour's plant was held on June 1, 1989. Demolition continued over the next year until the forty-seven-acre site was open for new development. *Fred Crosby, photographer.*

many kids in their teens today wouldn't even think of, like fishing, bike riding, sports and just general adventuring. For me, summers in the mid-1980s meant spending my days on the shores of the Mississippi River, fishing, shooting BB guns and wrist rockets, building fires and doing all sorts of other things that would be frowned upon by society today, just thirty or so years later.

Now, most folks don't care to fish by themselves, and I was no exception. In addition, my parents had a rule that if I was fishing down at the river, I had to be with a buddy (so we could get in trouble together…). I had a cousin who lived across the river in Cottage Grove. He was to me what Tom Sawyer was to Huck Finn. If his mom didn't want to drive him over, no worries. This was in the last days of the Rock Island swing bridge from Newport to Inver Grove Heights, and he could bike across for a dime. Either way, we made it work, several days a week.

A typical day's trip would start with getting some simple gear together, obviously a fishing rod and reel were important. My trusty Crosman 488 carbine in a case, with a few hundred copper BBs, some lead sinkers or assorted nuts and bolts for weight, a lighter or matches, pocket knife, fork and spoon, a few slices of bread or hot dog buns and maybe a hatchet or machete. All this got lashed to the handlebars of our bikes in cases and duffel bags. We stopped for provisions on the way.

We'd head down the hill at Grand, hang a left on Concord Exchange, and hit Country Club for bait and the day's food. Bait consisted of a can of whole kernel corn, usually Festal (three for ninety-nine cents), a pack of cheap hot dogs, some assorted Shasta (ten cans for a buck) and, if we had some extra coin, maybe a can of potatoes, baked beans or chili. From there, we headed north on Concord, toward Sobaskie's Bar and Central Avenue. That was our turn. At the time, there was a road down to the tracks, and a cut led down to the river. The Chicago Northwestern rail guys knew us by sight and would wave to us or hold us back if there was traffic heading our way on the main line. Occasionally, they would even come down on their lunch hour, just to see if we were catching anything.

Once through the cut between the demolition dump pile and the lowlands, there were two beaches divided by a culvert, most of it fronted by tow barge anchorage. Some days you had a great view of the land across the river, largely untouched by development, other days not so much.

We would try to arrive before 10:00 a.m. and usually fish until 4:00 or 5:00 p.m. We'd cut some Y sticks from willows to prop our rods up with them, if ours had disappeared from earlier trips, and settle into one of the

spots. We would bait our hooks with corn, toss them out and wait. While waiting, we would shoot cans, pretending they were Russians attacking (the original Red Dawn *movie was out for only a year or two at that time), build a fire for cooking lunch, whittle wood and have fun. More than once, while we were goofing off, a fishing rod would disappear. We got smart quick and started tying the rods to the sticks they rested on. Lunch was cooked over coals, and we would place the cans in them with the lids bent over for easier handling. Those were some great meals, at the time…*

Fishing varied by the day, the weather and the water level, but the targeted species was almost always the lowly carp. I will say, to this day, your odds of catching a ten-plus-pound freshwater fish is the best if you try for a carp, and they were a great fight. A good day might have meant catching ten to twelve fish between the two of us, and some of them were greater than twenty pounds. There were other species caught, like suckers, channel cats, walleye, sauger, small mouth bass and sheep's head, but it was the mighty carp we treasured. There was one day when my rod doubled over, and the drag on my trusty Mitchell 300 started screaming. I grabbed it, pulled back and watched the line peel off. I tried to slow the fish by putting my thumb on the reel to slow it and wound up with a dime sized blister. Shortly after, I lost that fish. When I reeled in my line (it hadn't broken), the hook on the end was as straight as a sewing needle. To this day, I still wonder what was on the end.

Unlike Paul, most residents had never been to the river in South St. Paul. When those first few souls showed up to help with early cleanup efforts, many of them had no idea how to even reach the river. REAP worked hard to bring people to the Mississippi, increasing familiarity and gaining support for public access. From 1989 to the present, the developments impacting the river trail, the railroad, Kaposia Park, the Exchange Building, the Armour's site and the creation of Kaposia Landing moved forward in remarkable ways.

Chronology of Action

- November 16, 1989: City council voted unanimously to support the River Trail and Boat Launch projects.
- December 4, 1989: The River Trail master plan was approved by city council. Mayor Katherine Trummer bought the first

share of community "stock" in the riverfront. The sales of "stocks" was a fundraising effort that REAP conducted for trail development funds.
- 1990: The HRA and the stockyards landowner, Canal Capital, began plans to consolidate the stockyard properties to open more land for new industrial and manufacturing operations. Chute Road was removed and Hardman Avenue was moved to the east to provide more accessibility to the new development areas in one of the most significant and successful decisions made during this phase of redevelopment.
- March 9, 1990: The mayor and council received word that the Chicago Northwestern Railroad was planning a massive expansion of railroad switching operations at its South St. Paul yards on the riverfront. Meetings and discussions had only begun with the railroad, county officials and local legislators to begin the process of gaining legal public access to the river in South St. Paul, access that was impossible at the time because the railroad, the stockyards and other private investors owned all the land along the Mississippi. Word of the expansion was a dramatic threat to those river access plans, and for the next year, council meetings were torn apart with division as the newly elected mayor and council members fought to stop the railroad project while those who were publically opposed to riverfront access supported the expansion. Town meetings, sponsored by REAP, were held, and neighbors came to testify about how the current level of railroad noise was so loud at times that objects flew off their book shelves during switching operations. The noise pollution on the top of the bluffs at the north end was so bad that several people were trying to sell their homes and leave town.
- May 17, 1990: The Celebrate South St. Paul 1990 Commission learned that South St. Paul was one of thirty cities chosen to compete for the honor of being named an All-America City because of three projects: the Centennial Celebration, the River Trail and the demolition of Armour's.
- June 2, 1990: The second annual Eagle Watch focused on two new eaglets in the nest on South St. Paul's riverfront.
- June 7, 1990: The South St. Paul contingent presented their case to the National Civic League in Phoenix, Arizona, and South St. Paul was named an All-America City. Darrol Bussler (director of

A Brief History

In August 1990, South St. Paul was named an All-America City by the National Civic League. Jodelle Ista and Tom Schmidt unveiled the city's new banners at a meeting of the South St. Paul/Inver Grove Heights Rotary Club. *Dakota County Historical Society.*

Community Education), Larry Dowell (executive director, South St. Paul/Inver Grove Heights Chamber of Commerce), Forrest Glewwe (chamber president), Lois Glewwe (South St. Paul city councilmember), David Hohle (chair of the REAP River Trail Action Team), Jodelle Ista (South St. Paul city councilmember), Dave Metzen (superintendent of schools), Leslie Metzen, Lois Swanson (REAP coordinator), Roy Swanson, Betty Thompson (artist and REAP Council) and Katherine Trummer (mayor) represented the city at the competition. Artist Betty Thompson's Spirit of the Eagle banner created for the presentation was awarded to the city and displayed in the council chambers until the most recent renovations.

- July 21, 1990: The first "official" Mississippi River Cleanup was held in South St. Paul with the sponsorship of the DNR and the River Revival group.
- August 5, 1990: Completion of the clearing of all trails throughout the ravines of Kaposia Park by the REAP Kaposia Connector

Team led by Jeri Leonard. The South St. Paul Jaycees painted the pavilion, a new refrigerator and stove were donated for the kitchen, the horseshoe pits were donated and installed and the Eagle Scouts donated signage for the trails. Labor for re-roofing the pavilion was also donated, and Parks and Recreation opened the first Frisbee golf course in the park.

- August 8, 1990: Mayor Katherine Trummer, Councilmember Lois Glewwe, Community Education director Darrol Bussler, Minnesota state senator Jim Metzen, Minnesota state representatives Bob Milbert and Tom Pugh went to the White House to accept personal congratulations from President George H.W. Bush on South St. Paul's being named an All-America City.
- August 15, 1990: The Seidl's Lake Task Force was formed by Representative Bob Milbert to work with Inver Grove Heights to create a joint recreational space on the lakeside property.
- September 15, 1990: The Third Annual River Ramble was held on the site of the proposed public boat launch under the I-494 bridge.
- October 15, 1990: The old metro waste site property on the river, named Packer Preserve, was transferred to city ownership.
- October 23, 1990: The city celebrated the award of the All-America City honor at a Community Potluck Supper and Celebration at the High School. The "Spirit of the Eagle" presentation as given in Phoenix was re-created for the audience.
- January 30, 1991: The "Spirit of the Eagle" Dinner to celebrate South St. Paul's All-America City status was held at the VFW with speaker Henry Cisneros, National Civic League president.
- March 2, 1991: The first Community Gathering to implement the ongoing projects named in the All-America City project was held at Divine Redeemer Hospital. New teams, which combined with the former REAP teams, included Marketing, Beautification, Stockyards Consolidation, Exchange Building, Trail and River Access and Effective Support Systems.
- June 25, 1991: The Community Gathering groups met at Kaposia Park and solidified the focus of their efforts as C-U in Action for Community Unity in Action. That same month, Mayor Katherine Trummer and school superintendent Dave Metzen reorganized Community Partnerships in an effort to continue community communication.

A Brief History

- July 20, 1991: The South St. Paul Housing and Redevelopment Authority received the Exchange Building back from Morris Kloster's estate. Kloster had died in January 1991.
- October 12, 1991: Fall Cleanup of the boat launch and dike wall was held.
- 1992: Ongoing activities for REAP and the C-U in Action teams focused on re-use of the Exchange Building and a proposal for a horse arena on the riverfront called Tanglefoot.
- Spring 1992: The HRA spent several thousand dollars on the Exchange Building, repairing the roof, shoring up the portico and removing asbestos and an underground storage tank. All of the floors were cleared of thousands of dead pigeons and other vermin that had infested the building.
- June 1992: The Dakota County Historical Society was allowed to hold public tours of the Exchange during Kaposia Days.
- July 1992: The city held a public meeting to discuss using the Exchange Building as a new city hall.
- February 10, 1993: Seidl's Lake master plan was approved by South St. Paul and Inver Grove Heights City Councils.
- February 26, 1993: First City Entrance Monument Beautification meeting held.
- July 6, 1993: The city held a public hearing on the ongoing situation concerning railroad expansion, finally agreeing on a rezone to Railroad Transportation for the property, which allowed the city some control over expansion.
- 1994: The HRA received permission to tear down the old Stockyards National Bank on the north side of the Exchange Building. It was felt that the property would be more marketable without the later addition.
- July 1995: The chamber of commerce and the HRA opened the Exchange again for development tours. Pigeons had once again infested the building, additional vandalism had occurred and no new development options were presented.
- August 23, 1995: The HRA granted REAP permission to hold the public tours of the Exchange Building.
- October 1995: REAP sponsored another town meeting to address what to do with the Exchange Building.
- October 12, 1995: REAP and the city learned of the proposed installation of a metal shredder by Alter Corporation on the

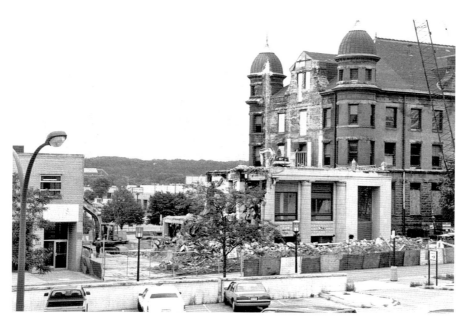

In 1994, the HRA received permission to demolish the Stockyards National Bank Building that was attached to the north side of the Exchange Building. The bank had undergone significant renovations from the 1950s to 1970s and had little historic integrity left. It was felt that removing it would make the Exchange more marketable. *Dakota County Historical Society.*

northern border of South St. Paul. This issue took up much of the community's focus for the next several years.
- 1996: South St. Paul Restorative Justice was created by Darrol Bussler and Lois Swanson in an effort to bring peacemaking and healing to individuals and families impacted by local vandalism and destructive behavior.
- February 17, 1996: South St. Paul City Council passed a resolution in opposition to the metal shredder.
- February 15, 1996: Duane and Martha Hubbs obtained a six-month option to purchase the Exchange Building for use as a hotel and restaurant.
- April 20, 1996: Groundbreaking ceremonies were held for the South St. Paul portion of the Dakota County Regional Trail.
- June 24, 1996: REAP offered the first South St. Paul Coverlet for sale to raise funds for trail amenities.
- July 1, 1997: Duane and Martha Hubbs's plan for the Exchange Building renovation was approved by city council.

A Brief History

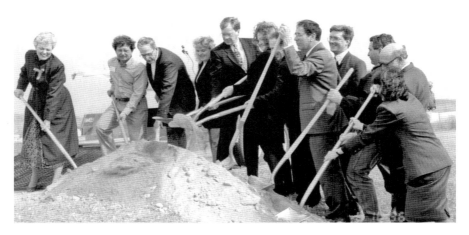

After only a few years of consistent and persistent negotiations with the railroad and other private property owners, the city was successful in being designated a part of the Dakota County Regional Trail System. Groundbreaking was held on April 20, 1996. *Left to right (listed with the position they held at the time)*: Jodelle Ista, Joe Kaliszewski and Ed Oster, South St. Paul city councilmembers; Lori Hansen, Parks and Recreation commission chair; Minnesota state senator Jim Metzen; South St. Paul mayor Kathleen Gaylord; Dakota County commissioner Don Maher; U.S. representative Bruce Vento; Tom Seaberg, Steve Sylvester and Norm Nistler, South St. Paul city councilmembers; and Randee Nelson, South St. Paul Parks and Recreation director. *Author's collection.*

- July 27, 1997: The Hubbs closed on the purchase of the Exchange and invested over $3 million in renovation.
- June 13, 1998: John Carroll Boulevard renamed back to Grand Avenue.
- Fall 1998: The Hubbs open the Exchange as the Castle Hotel. Several city council members picketed at the opening because a shortage of union workers had supposedly led the Hubbs to hire private laborers. The same council members also boycotted the city Christmas party, which was held at the Castle Hotel that December.
- January 2000: The Castle Hotel declared bankruptcy and closed.
- 2000: Renovation and reopening of Central Square Community Center.
- October 2001: Richard DeFoe purchased the Castle Hotel and opened Valentino's as a night club and catering center with Il Trevino Restaurant in the lower level.
- 2002: REAP began raising money for a sculpture by two Native American artists to commemorate Kaposia Village and the people of Little Crow's band.

- 2003: Dedication of the Grand Avenue pedestrian bridge over the railroad tracks to the river trail.
- June 2004: Great River Greening planted the Wild Flower Levee Park along the South St. Paul Regional Trail.
- July 3, 2004: The Grand Excursion, with dozens of paddle wheelers and steamers, came up the Mississippi River through South St. Paul. Hundreds turned out to watch.
- October 2004: Simon's Ravine Trailhead and bridge were completed.
- June 23, 2007: Dedication of the American Indian sculpture and Memory Path of Paver Blocks at Simon's Ravine. The sculpture was created by Native American artists Bill LeDeaux and David Estrada. REAP raised $23,000 for the commissioned sculpture. REAP ceased operations after the sculpture project was completed but remains a registered nonprofit corporation in the state of Minnesota and can be reactivated at any time.
- 2008: Opening of Kaposia Landing, the eighty-seven-acre site formerly known as Port Crosby. The city's first off-leash dog park opened on the site. Construction began in 2015 for new ball fields and facilities.

BridgePoint and New Challenges

Through all of the drama and trauma of the demolition of South St. Paul's downtown, the closure of the meatpacking plants and the economic challenges of the 1980s and 1990s, the South St. Paul HRA, city council and city staff; the River Heights Chamber of Commerce; and civic volunteers and activists kept moving forward. The livestock industry was still a major presence in the city until 2011, when Central Livestock ceased operations. The relocation of Hardman Avenue and the demolition of the Armour's plant had opened another forty-seven acres for new investment. Progress Plus, the economic development arm of the chamber of commerce, worked to market the new opportunities and the HRA provided financial assistance to a variety of clean manufacturing firms who gradually began populating the new space, which was named BridgePoint Business Park. The new development was anchored at the south end by the impressive new Bremer Bank, founded in the city as Drover's Bank in 1912; Drover's Inn, now the Clarion Hotel; and the Sportsman's Guide retail outlet. Longtime city businesses, Midwest

A Brief History

Today, the massive stockyards property is the site of BridgePoint Business Park, home to a broad range of diverse manufacturing and light industrial firms. The stockyards closed operations in 2008, and the last commercial slaughterhouse, Dakota Premium Foods, closed in 2015. It is estimated that there are as many employees in BridgePoint in 2015 that there were when Armour's closed in 1979. *South St. Paul Housing and Redevelopment Authority.*

Fence, various trucking operations and the infamous 24/7 Stockmen's Truck Stop continue to thrive in today's market.

Waterous built its international headquarters on the north end of the new park, and several local businesses, including S&S Tree Service and Bester Brothers, erected new buildings. Minnesota AFSME Council 5, Twin City Bagels, Holtkoetter Lighting and several other firms relocated to South St. Paul and erected new headquarters, and more than fifty businesses have moved into the new business center buildings constructed by the HRA. Hardman Avenue has become a gracious tree-lined roadway through a truly lovely area where thousands of people are employed.

In recent years, the city has received complaints from the public about the offensive odors from the last vestiges of the meatpacking-related industries, such as the Sanimax rendering plant, Twin City Hide, Twin City Tanning and a crematorium owned and operated by the Veterinary Hospitals

Association. Studies are being done, and the companies are cooperating. Dakota Premium Foods, the last commercial slaughterhouse, shut down in 2015 because changes in the meatpacking industry had led to a reduction in the number of cattle being shipped to market and productivity was unsustainable. Today, most meatpacking operations are located in small towns near the growers.

In 2015, the city is awaiting the opening of a new Kwik-Trip market on Armour Avenue at Concord even as the community mourns the closing of its last bakery, Joe's, in 2006 and it's last pharmacy, Pro, in 2015. Retail opportunities are declining, and in a city that at one time supported dozens of groceries, drugstores, hardware stores, dress shops, beauty parlors, men's shops, bars and restaurants, it's hard to get used to being simply a bedroom community. Still, the community is also home to dozens of new young families who love being here because of the city services, neighborhood charm, the well-kept houses, the parks and schools, the recreation opportunities and the public library.

A Word from Mayor Beth Baumann

In the closing pages of the 1987 South St. Paul history, Mayor Bruce Baumann shared his thoughts about the city's future. I asked his daughter, current South St. Paul mayor Beth Baumann, to do the same for this new history.

> *South St. Paul has changed and reinvented itself after every setback and downturn for over 125 years. Some of the changes in the past 25 years—the last trading day at the Central Livestock Exchange in 2011 and the closing of the last packing plant in 2015—sadly eliminated the last vestiges of our "Cow Town" history. But we reinvented the stockyards site with a new, diverse development with a stronger, more balanced tax base and companies offering jobs at all levels and goods and services for a range of industries.*
>
> *The economic downturn in the 2000s had thousands of community residents out of work, our state Local Government Aid (LGA) cut in half, and all economic development came to a halt. The city leaders took a serious look at the source of city revenues and lessened its dependence on LGA. This review also drove structural change in the way the city is run—aligning more staff in the areas of Public Safety and Public Works and contracting or trimming staff in areas that were not core services.*

These efforts created the merger of the South St. Paul and West St. Paul fire departments to form the South Metro Fire Department, an effort in the making for over twenty-five years, in 2008. The SMFD serves both communities from two stations and continues to provide the citizens, the businesses and firefighters safe and efficient fire and medical services.

Throughout all of the changes, South St. Paul continued to have a great sense of community, a strong work ethic and pride in our culture of caring neighbors. As South St. Paul looks into the future, one of our challenges is instilling those values into our children. How do we build the same culture of caring and community in our youth?

The Mayor's Youth Task Force is made up of youth from the fifth to twelfth grades who "Find Things to Do in SSP," and it may help build that sense of community. The task force creates, plans and runs fun activities and service events for youth to keep them from destructive behaviors like drinking, drugs and vandalism. Their activities range from Swimming Under the Stars to the All-City Food Drive and the Fill the Backpack Campaign. This group of kids gets involved and active in South St. Paul and develops leadership and planning skills along the way—I think it's working!

The future will also bring more focus on economic development to bring more business into South St. Paul. This will continue to broaden our tax base and increase revenue. We will see our development efforts shift up the hill to rebuild our commercial area into a walkable center for residents throughout the community. New parks, playing fields and gathering spaces will be developed to take advantage of our river access and open spaces.

South St. Paul has learned to adapt and change through all of its tough times to continue to be a community that thrives, not just survives. Let's continue to be neighbors who make South St. Paul a great place to live, work and play!

9
Gangsters, Governors, Flames and Foot Longs

The Perils of Prohibition

From 1887 to 1915, council minutes and local directories mention 107 taverns in the city. It is not an exaggeration to say that nearly every other doorway on Concord Street led into a bar or to a staircase to a bar in the basement or the second floor of another business. When the federal government outlawed the sale of liquor under the Volstead Act of January 16, 1919, the manufacture, sale or transport of alcoholic beverages was prohibited. For a city like South St. Paul, which depended on liquor sales to keep the cattlemen, stock brokers, bankers and yard men in town and spending money, Prohibition, as the era came to be called, had the potential to be economically devastating.

Several people who lived in town during this time were interviewed by Myrtle Allen for the 1987 South St. Paul centennial history publication. They described how many local establishments produced, sold, stocked and profited from illegal liquor. Moonshine stills operated in many basements in the establishments along Concord Street, where a tunnel reportedly existed along the entire length of the lower basement level. Waitresses and barkeepers would keep a close eye out for federal agents and quickly switch a glass of whiskey with a cup of coffee whenever the law showed up. Informants in St. Paul would reportedly call local South St. Paul Police and tell them that the Feds were on the way to town. Two boys from the corner drugstore would run up and down the street shouting the warning, and

businesses would signal one another through a special street code that could include pulling a window shade up or down or through some other sign.

Many boardinghouse owners also made moonshine in homemade stills, and their tenants would smuggle it into their workplaces and sell it during the day. One legal way to purchase whiskey was for medicinal purposes. Doctors could write a man a prescription for whiskey and charge him three dollars, and then the drugstore owner would charge another three dollars, resulting in a pretty expensive pint. One resident surmised that there were at least ninety-two locations to buy liquor along Concord Street all during Prohibition.

Gambling was also outlawed during this era, but illegal slot machines were all over town, often tucked away in the back of residential garages on the hill off the Concord Street strip. Other joints operated as speakeasies where knocking on a door that had a covered peephole would bring the proprietor, who would let the person in if he was known or knew the special password for that day.

In addition to all of this illegal activity, South St. Paul continued to bustle with business and had banks on all four corners of Grand Avenue and Concord Street during the Great Depression and Prohibition. Combining cash, liquor and gambling all in one small town was a huge draw for gangsters from all over the country.

I remember that I was in high school when the movie *Bonnie and Clyde* came out with Warren Beatty and Faye Dunaway. Several of us just fell in love with the story, the clothing and the whole crazy, violent drama of the times, and we saw the movie several times. One day, I was raving to my mother about how great the '30s were, and she confronted me with a frightening truth. She said those days were not happy; many families were destroyed by the results of gambling and liquor, and my own father was almost killed when gangsters in a big black sedan came tearing down Marie Avenue past his car dealership, shooting up the street. Bullets missed him by a hair. They weren't heroes or charming or glamorous my mother said. They were crooks who didn't care who got hurt. I don't think I ever saw the movie again.

Shootout on Concord Street

On the morning of August 30, 1933, gunshots rang out on Concord Street, killing South St. Paul police officer Leo Pavlak and wounding fellow officer John Yeamen. Six men in a big black sedan escaped with $30,000 in cash,

A Brief History

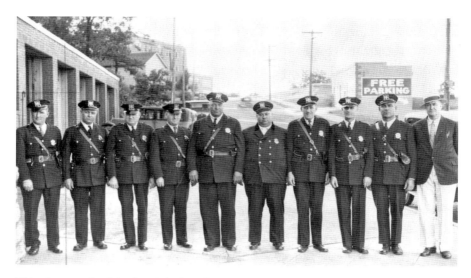

This photograph of the South St. Paul Police Department was taken in 1933 at some time before the 1933 holdup that left one officer dead and another seriously wounded. *Left to right*: slain officer Leo Pavlak, George Wagner, Art Giguere, Henry Whaley, Frank Farrell, Victor Johnson, Edward Giguere and Fred Schulze. Next to Schulze is John Yeamen Sr., the officer who was wounded in the shootout, and Chief Ed McAlpine is on the right. *Dakota County Historical Society.*

taken from the bank messengers in front of the post office on what is now Concord Exchange, leaving Officer Pavlak dead on the sidewalk and Officer Yeaman seriously wounded as he sat in his car in the driveway between the post office and the Great Western depot. The gangsters had been awaiting the arrival of the money on the train from St. Paul and began firing as the bank messengers, Joe Hamilton and Herb Cheyne, were intercepted and forced to deposit the money bags on the post office steps. Pavlak was shot while Hamilton and Cheyne ducked under a truck. One of the gangsters was shot in the back, but he was grabbed up and dragged into the getaway vehicle. A spray of machine gun fire was directed up and down Concord Street shattering windows and terrifying the crowds on the sidewalks and in nearby buildings. The gangsters fled north on Concord Street toward St. Paul. The crime was so well planned and executed that only a few minutes elapsed before the robbers were on their way. Their car had been parked in front of the George Egan filling station on Concord at Leitch Street since seven o'clock. Two of the attackers had been waiting in the Depot Café a few feet to the north. They sat down but kept looking out the window. They had two cases that looked like salesmen sample bags. When they got the signal

from outside that the shipment had arrived, they grabbed the bags, which fell open revealing a machine gun and sawed-off shot gun. South St. Paul Police chief Ed McAlpine immediately went to Minneapolis to seek assistance in tracing the men, whom he believed were still in the area. Dakota County attorney Harold Stassen, who arrived at the crime scene only moments after the shooting, assisted in the investigation by instructing passersby to collect and turn in any shells found in the street or other evidence. The identity of the robbers was never confirmed, but the stolen machine gun they used that day was recovered by the FBI in January 1935 when agents raided the Chicago apartment of Arthur "Doc" Barker, one of Ma Barker's sons and a member of the Barker/Karpis Gang. Alvin "Creepy" Karpis later admitted his part in the robbery in his 1971 autobiography. The Thompson machine gun is in the possession of the South St. Paul Police Department, a grim reminder of the tragic day when an officer was gunned down in the city.

Hijacked by Dillinger

On April 24, 1934, John Dillinger and his gang members, John "Red" Hamilton and Homer Van Meter, were fleeing the FBI after escaping from an attack at a closed country inn in Michigan. They had commandeered a Ford coupe in Park Falls, Wisconsin, and entered Minnesota at Red Wing. On U.S. 61 they headed for St. Paul but were spotted by authorities, who chased the blue car with guns blazing on all sides until Hamilton was shot in the back by a bullet while he was in the front passenger seat. Breaking the back window, Dillinger shot back and the chase continued for another fifty miles or so until the gangsters managed to lose the police at St. Paul Park. They crossed the Mississippi on the Inver Grove bridge and decided to head for Chicago. Needing to find a different vehicle, they intercepted a 1934 Ford V8 Deluxe on South Robert Street and Wille Road. The driver was none other than South St. Paul's Northern States Power Company office manager, Roy P. Francis. With him were his wife, Sybil, and their two-year-old son, Robert.

Little Bobby was apparently not at all worried and tried to grab Dillinger's gun. According to Sybil Francis, the gangster reportedly responded, "Don't worry about the kid. We like kids." The Francis family was forced to get back in their own car with the gangsters who stopped to buy gas and then let Roy, Sybil and Bobby out a mile down the road in Mendota, Minnesota.

According to reports of the time, the Francises' car was found a few days later in Chicago and bloodstains that marked the front seat indicated that the gangsters had used it to flee a shootout with the police earlier in the day. Robert's baby blanket and crib were still in the back seat, covered with the shattered glass which apparently had fallen when the rear window was smashed to enable the gang members to shoot their machine guns out the back of the vehicle.

John Dillinger was killed by federal agents in Chicago just three months later, on July 22, 1934, at the age of thirty-one.

THREE GOVERNORS

There aren't many Minnesota communities outside St. Paul and Minneapolis that can boast of producing even one governor, but South St. Paul can lay claim to three individuals who attained the highest office in the state: Harold E. Stassen, Harold LeVander and Tim Pawlenty. All three were elected as Republicans even though South St. Paul voters more often than not select Democrats to represent their interests at the state capitol.

Harold Stassen was born in 1907 on his father's farm in West St. Paul. In 1929, he married Esther Glewwe, whose father founded Glewwe's Groceries in South St. Paul in 1905. Stassen opened his first law practice in South St. Paul in 1929 and was elected Dakota County attorney in 1930, a position he held until being elected the youngest person to ever serve as governor of any state in the country in 1938. The state did not provide a Governor's Residence in those years, and Harold and Esther continued to live in South St. Paul's Pill Hill on Fifth Avenue North and then in a new home they built at 744 Stewart Lane. It was at their South St. Paul home that they entertained dignitaries from around the world. The house and its many modern conveniences were featured in a *Ladies' Home Journal* photograph spread in January 1946, and *LOOK Magazine* was in South St. Paul to photograph an eight-page story on the Stassen family and their home in August of that year.

Governor Stassen resigned shortly after being elected to his third term and went into active duty in the U.S. Navy in 1943. His lengthy public service in subsequent years included his work as a founder of the United Nations in 1945; president of the University of Pennsylvania, 1948–1952; member of President Dwight D. Eisenhower's cabinet from 1952 to 1958; and founder and

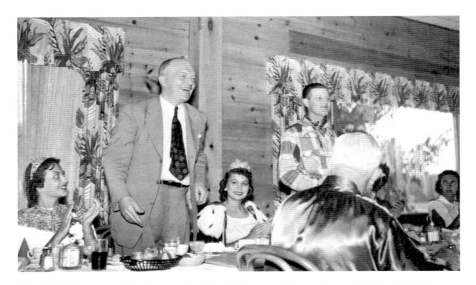

Harold E. Stassen, at left, is pictured with the Queen of Snows from the Saint Paul Winter Carnival and with Harold LeVander at the right. The photograph was taken at a South St. Paul Hook-Em Cow banquet at Southview Country Club in the 1930s. Both men were South St. Paul attorneys, city residents and civic activists before and during their years as governor of Minnesota. Harold Stassen was governor from 1938 to 1943 and Harold LeVander from 1967 to 1971. *Author's collection.*

partner of Stassen, Kostos and Mason law firm in Philadelphia from 1958 until 1978. The Stassens moved back to Minnesota that year and spent the final years of their retirement at their home in Sunfish Lake. Esther Stassen died in October 2000, and the former governor passed away in March 2001 at the age of ninety-three years.

Harold LeVander was born in 1910 in Swede Home, Nebraska, and came to Minnesota with his parents at the age of two years. He graduated from the University of Minnesota Law School in 1935 and joined Harold Stassen's South St. Paul law firm that same year. He served as assistant Dakota County attorney during the same years that Harold Stassen was county attorney. When Harold Stassen moved to Philadelphia, Harold LeVander became the lead attorney in the firm that became known as LeVander, Gillen and Miller of South St. Paul.

Harold LeVander married Iantha Powrie, whom he met while attending the University of Minnesota. They made their home in South St. Paul, eventually building their lovely home on top of the hill above Thompson Avenue where LeVander Estate Condominiums are today. Harold LeVander

was elected governor of Minnesota in 1966 and served from January 1967 through January 1971. While LeVander was governor, the family lived in the Governor's Residence on Summit Avenue, and Iantha LeVander was responsible for the renovation and preservation of the home during her years as Minnesota's First Lady.

After leaving the governor's office, Harold LeVander returned to his law practice in South St. Paul and passed away in March 1992 at the age of eighty-one. Iantha LeVander was ninety-six when she died on November 26, 2009.

South St. Paul's third governor was Tim Pawlenty, who was elected to the state's top position in 2002. Governor Pawlenty was born in 1960 and grew up in South St. Paul, the youngest of five children. His mother died of cancer when he was sixteen years old, and shortly afterward, his father lost his job. Tim Pawlenty became the first one in his family to go to college and worked his way through college and law school, graduating from the University of Minnesota.

Tim Pawlenty married Mary Anderson of Edina, Minnesota, in 1987, and both practiced law for several years. Mary Pawlenty was appointed a district court judge in 1994 and served as a judge in the First Judicial District until retiring in 2013. Tim Pawlenty entered politics through service on the Eagan City Council before being elected to the Minnesota state House of Representatives in 1992. He served ten years as a legislator, including four as house majority leader, before being elected governor in 2002. He entered the Republican race for president in 2012 but canceled his campaign after the Iowa primary and is currently president and CEO of Financial Services Roundtable, a Washington, D.C.–based industry advocacy group.

Fighting Fires

Fighting fires was always a top priority for South St. Paul from its earliest days. With Waterous Engine Works in town, the city had the opportunity to purchase state-of-the art equipment even though fires often were unable to be quenched because there was no water in the area to operate the steam engines. Two firefighters have been killed in the line of duty. George Carleton died on May 22, 1892, after falling into the fly wheel of the stockyard's feed elevator while battling a fire. It was seventy-six years before another firefighter lost his life. Jay Bloemers had been with the local fire

department for six years when the Coast-to-Coast store and neighboring barbershop and apartments at 121–27 North Concord went up in smoke on June 2, 1968. Bloemers was working on a ladder above the scene checking for any remaining embers when faulty welds gave way and the rig collapsed, impaling Bloemers on the handle that directs the nozzle of the hose apparatus. He was survived by his wife, Pat, and five children.

Other major fires include Standard Building Supply at 349 North Concord in 1951, the American Legion Dugout at 209–11 North Concord and Brand's Dimestore at 147 North Concord in 1960. The Moose Lodge at 357 North Concord burned in 1961, and a 1964 fire at the stockyards caused substantial damage. Glewwe's Grocery store on Fifth and Marie Avenues burned in July 1971, and the GFN Bar at 318 South Concord was consumed by fire on Christmas Eve morning at about 2:30 a.m. in 2000. The bar had survived urban redevelopment but couldn't survive the flames on that twenty-five-degree-below-zero morning.

South St. Paul firefighter Jay Bloemers, second from left, lost his life in a fire at the Coast-to-Coast store at 127 North Concord on June 2, 1968. He left behind his wife, Pat, and five children. *Dakota County Historical Society.*

A Brief History

Oh, for a Taystee-Freez Footlong

Generations of South St. Paul residents remember the bartenders, owners, customers and ambience of many of the dozens of bars, restaurants and pool halls on Concord Street. It wasn't until 1974 that Gene's Restaurant opened on the hill at 900 Southview Boulevard. Gene Rossi received the first liquor license on the hill, and his elegant supper club was the first opportunity residents had to experience dining above the Concord Street strip.

The hill, however, did have its own food attractions. Tony Mega opened the city's first drive-in at 1225 Southview Boulevard in 1946. He operated the business until 1956 when South St. Paul got its first Chinese restaurant. Herbert Wong bought the drive-in and moved the little building across the street to its current location at 214 Thirteenth Avenue South. Wong's Kitchen is still providing the best, by many accounts, Chinese food in the area in 2015.

By 1953, Frank and Eleanor Drkula opened a Taystee-Freez franchise at 101 Second Avenue South. Ken Schult Sr. and his wife, Delores, bought it, but by that time, Taystee-Freez as a franchise had been bought out. They

Tony Mega opened South St. Paul's first drive-in root beer and hamburger stand in what is today the southeast corner of Thirteenth Avenue and Southview in Southview Center's parking lot. The little stand was purchased by Herbert Wong and moved across Thirteenth, where Wong's Kitchen continues to serve the community today. *Linda Little Dietsch collection.*

decided to simply keep the sign up but operate independently. They invested in a Taylor Ice Cream machine, which is how they were able to make the vanilla/chocolate twist cones that so many people remember. They also occasionally produced strawberry ice cream with the new machine. Eventually, someone took over the Taystee-Freez name nationally, which is when the family had to change the name to the Skyline in the mid-1960s. Ken Schult Sr. died in 1968, and Delores and the kids ran the drive-in on their own. Delores died in 1973, and then in 1974 or 1975, there was a grease fire. Sandy Ewald was working at the time, and she sent someone to run over to the fire department about a block away to tell them the Skyline was on fire. The family rebuilt after the fire, but a few years later, they sold out to three local investors. Many people remember the twenty-five-cent foot-long hot dogs loaded with everything, the two-tone twist cones, the fried chicken and the burgers that came out of the stand. It was in an unusual place, away from any other business, which meant that a lot of city hall and library employees who were located in the neighborhood consumed many a take-out lunch from what everyone still calls the Taystee-Freez. The business closed by the mid-1980s, and the South St. Paul HRA purchased the building and demolished it to increase parking for the Nan McKay high rise across the street.

10
Before and After Images

In so many ways, pictures speak a thousand words. The following pages show before and after photos that highlight the major changes South St. Paul has experienced.

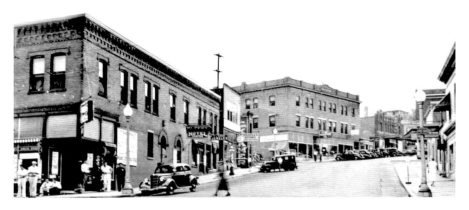

This photograph was taken looking west up the Grand Avenue hill in about 1930. The corner houses a drugstore and the Schult Building is the three-story brick building on the left. *Lou Ann Goossens collection.*

In 2015, the former Northwest Bank/Wells Fargo building (now empty) and the city's first and only skyway dominate the same view. *Kelly Rae Vo, photographer.*

A Brief History

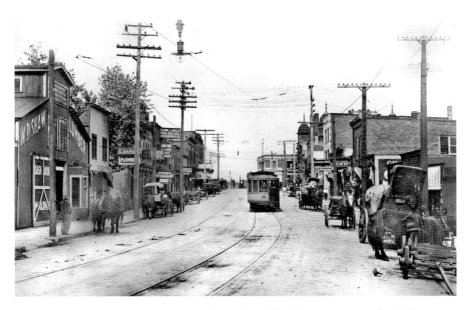

By 1917, South St. Paul was bustling with business. The first streetcar tracks had been laid in this photograph looking north on Concord Street toward Grand Avenue. The Exchange Building towers are visible in the background on the right. *Reinhold O. Werner photograph collection.*

In 2015, a view of Concord Exchange looking north toward Grand Avenue shows the former Wells Fargo bank building on the left and the Subway restaurant on the right. The towers of the Exchange are visible in the background on the right. *Kelly Rae Vo, photographer.*

South St. Paul

This is the south side of Grand Avenue between what is today Third Avenue North and Concord Exchange. The Hillside was the third manifestation of the movie theater that opened in 1914 as the Ideal. It was sold and renamed the Hollywood in 1938 and became the Hillside in 1953. It was torn down in 1973, and owner Mike Leitch opened a new South I and II Theater, which is Big Top Liquors in 2015. *Fred Grant, photographer.*

This is the south side of Grand Avenue at the theater location in 2015. The Grand Ridge apartment complex was built by the HRA and opened in 1988. *Kelly Rae Vo, photographer.*

A Brief History

Concord Street has been home to hundreds of bars and restaurants over the years. This photograph captures the last three in the 100 block of South Concord—Nick's, Sweeney's and the Hook-Em Cow—in about 1973. *Fred Grant, photographer.*

A view of Concord Exchange, formerly Concord Street, looking north from the 100 block south in 2015. *Kelly Rae Vo, photographer.*

South St. Paul

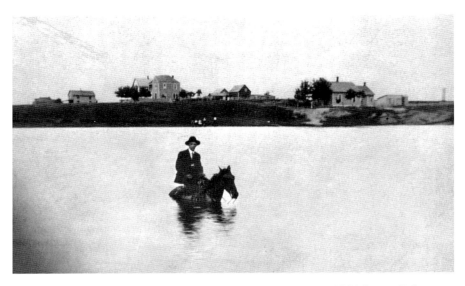

It's hard to imagine today, but this mud hole, kind of jokingly called Waldhauser Lake, extended on the south side of Southview Boulevard between Eleventh and Thirteenth Avenues South until the 1940s. That's George Waldhauser on his horse in the center of today's Twelfth Avenue South. *Author's collection.*

The mud hole is today the site of several homes and businesses along Southview and Twelfth Avenue South. *Kelly Rae Vo, photographer.*

A Brief History

In the 1970s, Marie Avenue was home to CJ's Restaurant, Jerabek's Bakery and the Neighbors Clothes Closet. *Fred Grant, photographer.*

This block of Marie Avenue is now home to Adult Basic Education and the South St. Paul Educational Foundation. *Kelly Rae Vo, photographer.*

Afterword

There are hundreds upon hundreds of stories of people, businesses, memories, major events and accomplishments that are not included in this brief history, which is intended to provide only an overview of the highlights of our history. Through the times of the burial mounds, the bustling livestock industry, the demolition of the 1970s and the rebirth of the 1990s, hundreds of people, businesses, organizations and churches have contributed to the survival of the city. In 1891, South St. Paul heeded the words of commission man Charles Fitch, who, speaking against annexation by St. Paul, said: "We had better stay outside and attend to our own business." For the next eighty-eight years, South St. Paul was dominated by our own business, and when we lost that business, another great depression, both psychological and economic, devastated the community. It has taken time to address and resolve those issues, and many challenges lie ahead. The one thing that has been consistent is the passion, loyalty and love that many feel for this riverfront town. We can't always explain why but we want to stay here, raise our children and grandchildren here and instill in them the same kind of bond with community that has kept us strong. May it always be so.

Bibliography

City of South St. Paul City Council Meeting minutes, 1887–Present, City of South St. Paul archives.

Glewwe, Lois, ed. *South St. Paul Centennial, 1887–1987: The History of South St. Paul, Minnesota*. Produced by the South St. Paul Area Chapter of the Dakota County Historical Society. Topeka, KS: Josten's Press, 1987.

South St. Paul Reporter and *South St. Paul Daily Reporter*, Minnesota Historical Society Newspaper Collections.

St. Paul Pioneer Press/Dispatch newspapers, Minnesota Historical Society Newspaper Collections.

Index

A

Adult Basic Education 161
Aiton, John 20, 21
Aiton, Nancy Hunter 20
Albu, Eva 59
Albu, George 59
All-America City 134, 135, 136
All-Class, All-City, All-Family Reunion 125, 126
Allen, Myrtle 145
Al's DX 78
American Family Insurance 92
American Hoist and Derrick 130
Americanization Council 61, 62
American Legion Dugout 152
Anderson, Clarence 94
Anglo-American Packing and Provision Company 44
Apostolic Christian Church. *See* Christian Apostolic Church
Armour & Company 45, 46, 47, 48, 53, 54, 62, 65, 91, 103, 107, 111, 120, 121, 124, 126, 129, 130, 131, 133, 134, 140, 141
Armour Place 120
Armour's. *See* Armour & Company
Asemblea Apostólica de la Fe en Cristo Jesús 76

B

Badalich, Steve 94
Bangs, Joseph 44, 45
Barker/Karpis Gang 148
Barsan, Aural 60
Bartl Ace Hardware 86
Bartl, John 59
Baumann, Beth 70, 71, 142
Baumann, Bruce 70, 71, 129, 142
Belisle, Mike 54
Benson, Constantine W. 26
Bester Brothers 141
Bethesda Lutheran Church 75, 76
Betty's Café 116
B&G Crossing. *See* Gerkovich's
Big Thunder. *See* Wakinyantanka
Big Top Liquors 158
Bircher School 88
Bircher, William 34, 88, 89
Blandings' Dream House 97, 99, 120
Bloemers, Jay 151, 152
Bloemers, Pat 152
Bly family 81
boat launch 130, 133, 136, 137
Bolles, Silas 76
Bowen, William 103
Brand's Dimestore 152
Bremer Bank 140

Index

Bretoi, Nicholas 59, 60
BridgePoint Business Park 140, 141
Brotzler, Charles 104
Brotzler, George 104
Brotzler, Jacob 104
Brotzler, Margaret Leidig 104
Brown, Margaret A. 76
Brunson, Alfred 18
Bryant, John H. 26, 29, 34
Buckboard 116
Bussler, Darrol 122, 123, 124, 125, 127, 134, 136, 138

C

Campbell Commission Company 103
Canal Capital Corporation 130, 134
Carleton, George 151
Carroll, John E. 117, 139
Castle Hotel 139
Celebrate South St. Paul 1990 Commission 134
Celestial Church of Christ 76
Cenex Corporation 116, 118
Central Livestock 140
Central School 73, 84, 85, 86, 87, 100
Central Square Community Center 85, 118, 126, 139
Chalupa, Joe 103
Cheyne, Herb 147
Chicago Northwestern Railroad 132, 134, 137
Choban, Nicholas 59
Christian Apostolic Church 59
Christmas in South St. Paul 122, 125
Civil Rights Act of 1964 63
CJ's Restaurant 161
Clarion Hotel 140
Clark, Arthur D.S. 28, 30, 79, 80
Clark, Arthur E. 26
Clark-Bryant Improvement Company 26, 79
Clark, Charles Wilbur 26, 28, 29, 30, 31, 33, 34, 47, 67, 79, 80
Clark & Company Grocery Store 31, 79, 80
Clark, Emilie 47
Clark, Emma Day 28, 34
Clark family 79
Clark, Lucy Larcom Spaulding 47

Clark Memorial Church 75
Clark, Susan Nechville 78
Coast-to-Coast Store 152
Colonial Properties 121
Committee of 40 113
Community Redevelopment Committee 113
Concordia Lutheran Church 76
Concord Street No. 1 Urban Renewal Project 114
Conlon, Thomas 103
Cook, Sylvester 20
Corneia, Bob, Sr. 112
Coulter, John 21
Country Club Grocery 118, 132
Coxhead, John H. 36, 88
Croatian Hall 58
Croatian Tamburitza Orchestra 67
C-U in Action 136, 137

D

Daft Electrical Company 31
Dakota County Historical Society 17, 119, 127, 137
Dakota County Regional River Trail. *See* River Trail
Dakota people 17, 20, 22, 24, 104
Dakota Premium Foods 141, 142
DeFoe, Richard 139
Denney, W.J. 37
Depot Café 147
Dieter, Norman 48, 49
Dillinger, John 148, 149
Dillon, Herb 97
Doichita, Stefan 59
Donnelly, Ignatius 36, 37, 38
Dowell, Larry 135
Drkula, Eleanor 153
Drkula, Frank 153
Drover's Bank 111, 112, 116, 140
Drover's Inn 140
Dunne, W.H. 36
Dwane Iron Works 26

E

Eagle Watch 130, 134
EDA. *See* South St. Paul Economic Development Authority
Ed's Grocery 94
Enos Railway Company 31, 32

Index

Estrada, David 22, 140
Ewald, Sandy 154
Exchange Building 27, 36, 37, 38, 43, 53, 67, 111, 116, 121, 126, 129, 133, 136, 137, 138, 139, 157

F

Farmer's Union Central Exchange 116
Farrell, Frank 147
Farwell, Ozmun and Kirk 117
Fearing, Mrs. John E. 69
Fifth Avenue Plaza 95
First Calvary Baptist Church 76
First Presbyterian Church 75
First United Methodist Church 76
Fitch, Charles 37, 38, 39, 163
Fleischacker, Joseph 92
Fleming Field 95
Flowers, Mark D. 45
Forsythe, Robert 103
Francis, Augustus 63
Francis, Robert 148, 149
Francis, Roy P. 148
Francis, Sybil 148
Francis, Zoe Giguere 70
French, Paul 77
Frez-R-Pak 94
Frownfelter, Karen 70
Fuller, Louis 48

G

Gaylord, Kathleen 70, 71, 139
Gebhart, Susie Zahnen 45
Gebhart, Wallace 44, 45
Gene's Restaurant 153
George Egan Filling Station 147
Gerkovich's 86
German Baptist Chapel 75, 77
GFN Bar 116, 152
Giguere, Arthur 78, 147
Giguere, Edward 147
Gilbert, Cass 28, 29
Gillen, Arthur 113
Glewwe, Forrest 135
Glewwe, Henry 83
Glewwe, Lois 70, 124, 125, 130, 135, 136
Glewwe, Rollin B. 113
Glewwe's Grocery 83, 86, 149, 152
Globe Printing and Office Supplies 116

Golden Oaks Nursing Home 95
Golden Steer Motel and Restaurant 95
Governor's Design Team 129
Grace Lutheran Church 76
Grannis, David L. 69
Grannis, Macha Vance 69
Grant, Myron 103
Grove, Sue Oestreich 81
Gutzmann, Micky 70

H

Hamilton, Joe 147
Hamilton, John "Red" 148
Hansen, Lori 70, 139
Harren, Betty Frances Marguth 116
Healy, Helen 70
Henness, A.E. 63
Hillside Movie Theater 118, 158
His Red Nation. *See* Taoyateduta
Hodgins, Eric 97, 98
Hohle, David 135
Holland and Thompson Manufacturing Company 26
Hollywood Movie Theater 158
Holtkoetter Lighting 141
Holtorf, Delores 94
Holtorf, Kenneth 94
Holtorf, Kevin 94
Holy Trinity Catholic Church 55, 56, 75
Holy Trinity Catholic School 56, 75
Hook-Em Cow Bar 117, 150, 159
Horst, Bill 116
Horst, Dan 116
Horst, Everett "Ed" 116
Horst, Mark 116
Hough, Sherwood 21
HRA. *See* South St. Paul Housing and Redevelopment Authority
Hrvatski Dom Association 58
Hubbs, Duane 138, 139
Hubbs, Martha 138, 139
Huntington, Peewee 78

I

Ideal Movie Theater 158
Illetschko's Meats and Smokehouse 94
Il Trevino Restaurant 139
Ista, Jodelle 70, 135, 139

INDEX

J

Jefferson School 75, 97, 98, 100, 102
Jerabek's Bakery 161
Jerhoff, Dorothy Rund 70
Jestus, Tom 100
Jitney Bus Company 94
Joe's Bakery 92, 142
John and Jane's 94
Johnson, Victor 147

K

Kaliszewski family 45
Kaliszewski, Joe 130, 139
Kaposia Band 17, 18, 20
Kaposia Days 123, 124, 125, 126, 137
Kaposia Education Center 84, 93, 94
Kaposia Landing 115, 133, 140
Kaposia name 18
Kaposia Park 17, 22, 82, 88, 89, 126, 129, 133, 135, 136
Kaposia Village 18, 19, 20, 21, 22, 23, 24, 73, 88, 139
Kassan, Eva 97
Kassan, Marilyn 97
Kassan, Mike 92, 96, 97, 99, 120, 121
Kavanaugh, Benjamin 18
King, David 18
Klectatsky, Joseph 33
Kloster, Morris 121, 129, 137
Kochendorfer, John 37
Kocher, Emilie Hartnagel 23
Kocher, Josiah 23
Kramer, George 69
Kramer, Theresa Tiedman 69
Kuckler, Conrad 69
Kuckler, Ida 69
Kwik-Trip 142

L

LaDeaux, Bill 22
Lancer & Associates 129
Lanegran, Virginia 70
Lawrence, Cecil 54
Lawrence, Iris 54
Lawrence, Joseph 32
Lawshe, Fred 33
Leary, Kristin Machacek 100

LeDeaux, Bill 140
Lee Livestock 103
Leitch, Mike 118, 158
Lencowski, Frank 55
Leonard, Jeri 136
Lesch, Thomas 103
LeVander, Gillen and Miller 150
LeVander, Harold 149, 150, 151
LeVander, Iantha Powrie 150, 151
Lienau, Charles H. 36, 37
Lienau, Marcus 36, 37
Lincoln Center 84, 85, 94
Lincoln Hotel 116
Lincoln School 35, 73, 79, 81, 82, 87, 93
Lindblom, Dave 79, 80
Lindell, Robert 103
Little Crow V. *See* Taoyateduta
Lloyd, Ezra 103
Lorraine Park 93
Lowe, Earl 103
Lowe, Thomas 103
Luther Memorial Church 75

M

Machacek, Janice 100
Machacek, Leonard 100
Maher, Don 139
Mattie's Lanes, Sports Bar & Grille 118
Mayor's Youth Task Force 143
McAlpine, Ed 147, 148
McDonald's 95
McLain, Chick 93
McLain Swimming Pool 93
McMorrow Field 96
Mdewakanton Dakota 17, 18, 88, 104
Mega Furniture 85, 86
Mega, Tony 153
Messenger, Addis 21
Messenger, Mrs. Addis 23
Metzen, Dave 122, 124, 135, 136
Metzen family 45
Metzen, Jim 130, 136, 139
Metzen, Leslie 135
Michelmore, Katherine 69
Michelmore, Katie 69
Michelmore, Thomas T. 69
Milbert, Bob 130, 136
Millie's Grocery 96
Minnesota AFSME Council 5 141

INDEX

Minnesota Packing and Provision Company 44
Miracle Centre of St. Paul 100
Mleczko, Anton 93
Moe, Arthur D. 36
Moose Lodge 152
Motor Parts Service 112
Motu, Eli 61
Motu, Ella Choban 61
Motu, Nick 61, 130
Musta, Eva 59
Musta, George 59
Mysteries of History 126

N

National Register of Historic Places 27, 57, 60, 61, 121
Neagoe, Emil 59
Nechville, George 77
Nechville's Grocery 77
Neighbors Clothes Closet 161
Nelson, Randee 130, 139
Newburgh, Louis H. 69
Newburgh, Marguerite 69
Nick's Tavern 116, 117, 159
Nistler, Norm 139
No-Name Steaks 94
Northern States Power Company 148
Northview Park 81
Northview Swimming Pool 81, 82
Northwestern National Bank 118, 123, 125, 156

O

O'Brien, Paul 130
Oestreich, Lorraine 81
Oestreich, Marvin 81
Old World Pizza 95
Olson, Sharon Nechville 77
Oster, Ed 139
Osterloh, Ed 94
Otto Bremer South St. Paul Hall of Excellence 126

P

Paape's Corral 116
Packer Preserve 136
Packer River Terminal 130
Page's Café 112
Pavlak, Leo 146, 147
Pawlenty, Mary Anderson 151
Pawlenty, Tim 149, 151
Pechanec, Joe 76
Pechanec, Katie 76
Peterson, Ewald 103
Pizza Factory 95
Polish Hall 55, 56
Polish Zagloba Society 55
Port Crosby 115, 130, 140
Prince, Thomas 93
Progress Plus 140
Pro Pharmacy 142
Pugh, Tom 136

R

REAP. *See* River Environmental Action Project
Rechtzigel, Anton 94
Rechtzigel, Florence 94
Reed, Charles A. 26
Reising, Leonard 83
Reising, Ruth 83
restricted housing covenants 63
Ries Electric 116
Rifkin's Meatpacking 48
Rindfleisch, Adolph 103
River Environmental Action Project 22, 127, 129, 130, 131, 133, 134, 135, 136, 137, 138, 139, 140
River Heights Chamber of Commerce 140
Riverside School 35, 76, 77
River Trail 89, 127, 129, 130, 131, 133, 134, 135, 136, 138, 139, 140
Robertson, Andrew 21
Rolle, Leo 103
Roosevelt School 73, 75, 87, 88, 91, 92, 93
Rosenberger, Gary 59
Rossi, Gene 153
Rosvold, Don 104
Rosvold, Gladys Brotzler 104
Rothecker, Marilyn 70
Royal Star Furniture 118
Rund, Harry E. 63
Rund, Jane 70

INDEX

S

Saddle City Committee 113
Sanimax 141
Sarafolean, John 91
Schmidt, Tom 135
Schult Building 156
Schult, Delores 153, 154
Schult, Ken, Sr. 153, 154
Schulze, Fred 147
Seaberg, Tom 139
Seidl's Lake Task Force 136, 137
Serbian Cultural and History Center 57
Serbian Home 56, 57
Serbian Mothers 67
Servatius, Bernard 107
Servatius, Gail 107
Servatius, Jim 85, 107
Servatius, Virginia 107
Simon, John 38, 88
Simon School 88
Simon's Ravine 18, 19, 73, 79, 88, 89, 140
Skyline 154
Smith, Richard K. 33
Snowball. *See* Verdier, Charles
Sobaskie's Bar 132
South and West Transit Company 94
South End Community Club 94
South I and II 118, 158
South Metro Fire Department 143
South Park Post Office 79
South St. Paul Airport 95
South St. Paul Assembly of God Church 76
South St. Paul Centennial Commission 126
South St. Paul Chamber of Commerce 112, 113
South St. Paul Chapter of the Dakota County Historical Society 124
South St. Paul Choralettes 122
South St. Paul City Hall 17, 34, 35, 36, 38, 47, 63, 83, 88, 123, 125, 129, 137
South St. Paul Civic Arts Commission 122
South St. Paul Commercial Club 75
South St. Paul Community Partnerships 124, 136
South St. Paul Daily Reporter 36, 38, 69, 88, 126
South St. Paul Depot 27, 53, 147
South St. Paul Economic Development Authority 120, 121
South St. Paul Educational Foundation 161
South St. Paul Futures 120, 121
South St. Paul High School 61, 84, 85
South St. Paul Hispanic Seventh Day Adventist Church 76
South St. Paul Housing and Redevelopment Authority 113, 114, 115, 116, 117, 120, 121, 130, 134, 137, 138, 140, 141, 154
South St. Paul/Inver Grove Heights Chamber of Commerce 135
South St. Paul/Inver Grove Heights Rotary Club 135
South St. Paul Jaycees 122, 123, 136
South St. Paul Junior High 84, 85, 94
South St. Paul Male Chorus 122
South St. Paul Police Department 34, 147
South St. Paul Post Office 21, 111, 112, 116, 147
South St. Paul Public Library 17, 82, 101, 142
South St. Paul Rapid Transit Elevated Railway Company 31
South St. Paul Reporter. *See South St. Paul Daily Reporter*
South St. Paul Restorative Justice 138
South St. Paul Rod and Gun Club 95
South St. Paul Sun-Current 126
South St. Paul VFW Post No. 295 136
Southview Country Club 103
Southwest Review 126
Sportsman's Guide 140
S&S Tree Service 141
Standard Building Supply 103, 152
St. Andrew's Episcopal Church 76
Stassen, Esther Glewwe 103, 149, 150
Stassen, Harold E. 103, 148, 149, 150
Stassen, J. Robert 123
St. Augustine's Catholic Church 75, 87
St. Augustine's Catholic School 75, 87
Steele, Franklin 21
Stickney, Alpheus Beede 25, 26, 27, 28, 30, 31, 34, 36, 37, 41, 44, 45, 47, 84
Stickney School 35, 83, 84
St. John Vianney Catholic Church 75, 83
St. John Vianney Catholic School 75, 83
St. Mary's Coptic Orthodox Church 76
Stockmen's Truck Stop 141
Stockyards National Bank 116, 137, 138
St. Paul Union Stockyards 26, 37, 41, 45, 49, 61, 69, 103, 107, 116, 124, 141, 142

INDEX

St. Paulus German Lutheran Church 75, 76
St. Sava Benevolent Society 56
St. Sava Serbian Orthodox Church 75
St. Stefan Romanian Orthodox Church 59, 60, 61, 75
Suskie, Paul 37
Swanson, Lois 135, 138
Swanson, Roy 135
Sweeney's 117, 159
Swift & Company 44, 45, 47, 48, 49, 53, 62, 65, 66, 107, 111, 114, 115, 116, 117, 120, 125
Swift's. *See* Swift & Company
Sylvester, Steve 139

T

Taoyateduta 19, 20
Taystee-Freez 153, 154
Thompson, Betty 123, 135
Thompson Heights 83
Thompson, James 18
Tiedman, Edward 91
Town Drug 95
Town Square Television 126
Tregilgas, Harold 103
Trinity Norwegian Lutheran Church 76
Trkla, Ted 57
Trudeau, Michael 94
Trummer, Katherine 70, 71, 129, 130, 133, 135, 136
Twedt, Andrea 89
Twedt, Dorothy "Dode" Weir 89, 90
Twin City Bagel Company 141
Twin City Hide 141
Twin City Tanning 141

U

Uncle Louie's Restaurant 116
United Packinghouse Workers of America 49, 50, 114

V

Valentino's 139
Van Meter, Homer 148
VEAP. *See* Volunteer Emergency Acquisition Program
Veith, Cindy 70

Vento, Bruce 139
Verdier, Charles 63, 64
Verkennes, Bob 122
Veterinary Hospitals Association 142
Viking Pop 95
Voluntary Emergency Acquisition Program 115

W

Wagner, George 147
Wahpeton Dakota 19
Wakinyantanka 18, 19
Wakota Arena 125
Waldhauser, George 160
Warner and Hough Machine Company 26
Washington School 73, 75, 77, 79, 91, 93, 94, 96
Waterous Company 28, 117, 141, 151
Waterous, Frederick 37
Wegener's Grocery 92
Weir family 89, 90
Weir, Francisca Karnstedt 89
Weir, John 89, 90
Wells Fargo Bank 156
Wells Fargo Lanes 118
Wentworth, George 30, 34
Whaley, Henry 147
Williamson family 20
Williamson, Jane S. 20, 21, 175
Williamson, Thomas S. 19, 20
Wilson, Gertrude 70
Wilson Heights 88
Wilson School 73, 87, 88, 90, 91
Winter, Brian 91
Wong, Herbert 153
Wong's Kitchen 153
Woods, Joe 92
Word Church International 100

Y

Yeaman, John "Jack" 64, 146, 147
Yeamen, John, Sr. 147

Z

Zins, Robert 123

About the Author

Lois Glewwe was born and raised in South St. Paul, Minnesota, the daughter of Reuben and Ethel Hymers Glewwe. She graduated from South St. Paul High School and the University of Minnesota and received her master's degree in Southeast Asian studies/Indian art from the University of Pennsylvania in Philadelphia. She did postgraduate work in New Delhi, India, for a year and returned to the States to work as the rights and reproductions director and curator of Indian art at the Philadelphia Museum of Art. She came back to South St. Paul in October 1985 and was hired by the City of South St. Paul to plan and coordinate the city's centennial celebration in 1987 and by the South St. Paul Chapter of the Dakota County Historical Society to produce the 528-page history of the city. In 1989, she was hired to write *The History of West St. Paul, 1889–1989*, and in 1990, she contracted with City of Inver Grove Heights to write *Inver Grove Heights: Minnesota's Treasure*. Glewwe is also the author of *The Glewwe Family History*, published in 1999; the *Memoirs of George Schulte*, published by the North American Baptist Heritage Commission in Sioux Falls, South Dakota, in 2002; and "The Journey of the Prisoners" in *Trails of Tears: Minnesota's Indian Exile Begins*, published by Prairie Smoke Press in 2009. For the past several years, she had been studying the history of the Dakota Mission in Minnesota, with special focus on Jane Williamson. She received an independent research fellowship from the Minnesota Historical Society in 2014 and continues her studies in the field today.

Visit us at
www.historypress.net
..
This title is also available as an e-book